Invasion of the Swamp Creatures

The Trump Administration from one Cartoonist's pen

Charles Ray

Uhuru Press

North Potomac, MD

This is a work of political satire. It does not intend to offend any ethnic, religious, gender, or other group, beyond the smug politicians who constantly try to pull the wool over our eyes. The material appearing in this book represents the opinion of the author and artist, and is not endorsed by, nor representative of any other person or organization. Like most political satire, it is biting, and no punches are pulled. Any resemblance to actual events, organizations, or individuals, living or dead, is well-meant, as factually based as possible, but intentional—after all, it is satire, and we're talking about public figures here.

The reproduction or distribution by any means, including electronic, is expressly prohibited without the explicit written consent of the copyright holder, except for fair-use quotes in connection with reviews or promotion.

For information about this and other works by this author, the author can be contacted at charlesray.author@gmail.com, and most of his published work can be seen at https://charlesray-author.com.

Cover art by the author. Cover design by author using EasyCoverBuilder.com

Printed in the United States of America.

Copyright © 2019 Charles Ray

All rights reserved.

ISBN-13: 9781795894616

DEDICATION

This book is dedicated to the more than 800,000 federal workers furloughed or forced to work without pay during the longest partial government shutdown in the history of the United States; people who faithfully executed their duties despite the callous and uncaring attitudes of the political class, and the man who engineered a 'crisis' at the southern border to try and force the congress to aid and abet the building a monument to his monumental ego and help him keep a promise to his base that grew out of an attempt by his handlers to get him to focus on issues. Americans seldom give much thought to the many government workers who ride with them on the subways or join them in their daily commute, until they're no longer available to provide the services that we too often take for granted. They are our neighbors, our fellow passengers, but more importantly, they're the ones who keep us safe, who process our tax refund checks, keep our national parks clean, and welcome us when we visit national historic sites. Like the air we breathe, they're often invisible to us, but boy, do we miss them when they're no longer there..

ACKNOWLEDGMENTS

I suppose I should thank Donald Trump, and the poor misguided people who, out of their anger and frustration, elected him, for the inspiration for what I think is some of the best political art I've ever done. When I was an editorial cartoonist for *The Spring Lake News*, in Spring Lake, NC, in the 1970s, the town's city council, Reagan, Carter, bit oil, Russia and the Ayatollah provided me with a pretty steady stream of ideas for cartoons. After that gig ended, there followed a long stretch—I mean, like decades, when I was seldom inspired to wield my pen for anything other than the occasional cartoon for a member of my staff at whatever embassy or consulate I was assigned to—I retired from the army and joined the US Foreign Service in 1982—and then along came Donald J. Trump. A real estate developer, best known perhaps for the number of times he's filed for bankruptcy than anything else, and reality TV personality—I have to confess, after seeing a trailer for his show, 'Celebrity Apprentice,' I passed on watching, as I do for all other reality TV shows, which I consider mindless exercises in ego stroking, and embarrassing. His campaign got everyone's attention; not because they thought he could win, but because it was so outrageous. It got my attention, because I noticed how the beer-guzzling bubbas were responding to his often-profane pronouncements and over-the-top rhetoric. When he began to knock off his GOP opponents, with his gutter tactics and take-no-prisoners style, and it appeared that the Republicans were bowing to the inevitable—he'd be their candidate, I began to be inspired. Since his inauguration in 2017, I've been inspired—more like angered—on an almost daily basis to grab my pen and capture the absurdity of the Trump Swamp, which is my nickname for the White House these days. So, thank you, all of you. I hope you're happy now.
.

THE FIRST WHIFF OF SWAMP STINK – AND, IT AIN'T OVER YET, FOLKS

Donald J. Trump hit the political scene like a meteor from deep space plunging into the middle of the ocean. He created a tsunami of political and social change whose impact was felt far beyond the shore of the United States, and whose effects are likely to be felt for decades to come.

Trump promised, if elected, to drain the swamp that was the Washington, DC establishment. Instead, he has restocked it, creating what has become one of the most corrupt White House administrations in American history.

The reek of fetid swamp air was floating around during the campaign, and I think I caught a whiff of it, but it really got heavy after the man was in office and started appointing people to positions. A coal lobbyist to run EPA, a neurosurgeon to run Housing and Urban Development (the token black cabinet appointment as well), and on and on. The campaign rhetoric, which was, in its level of vulgarity and disregard for truth, shocking enough, was not put aside once the oath of office was taken. If anything, it escalated. We starting pulling out of treaties right and left, insulting our traditional allies, and cozying up to our adversaries. The bromance between Trump and Russian dictator Vladimir Putin is especially noteworthy.

At any rate, I began to put draw my thoughts during the campaign. I've shared some of them in *Making America Grate Again*, but so much has happened since that book was published, I just had to share that output.

I hope you'll like these drawings. If you're a Trump supporter, and you've bought this book by accident, it's not personal, just the way I see things. If you're not a Trump supporter, you already know what I mean, but I hope you'll like my particular interpretation of events.

Read on, and enjoy.

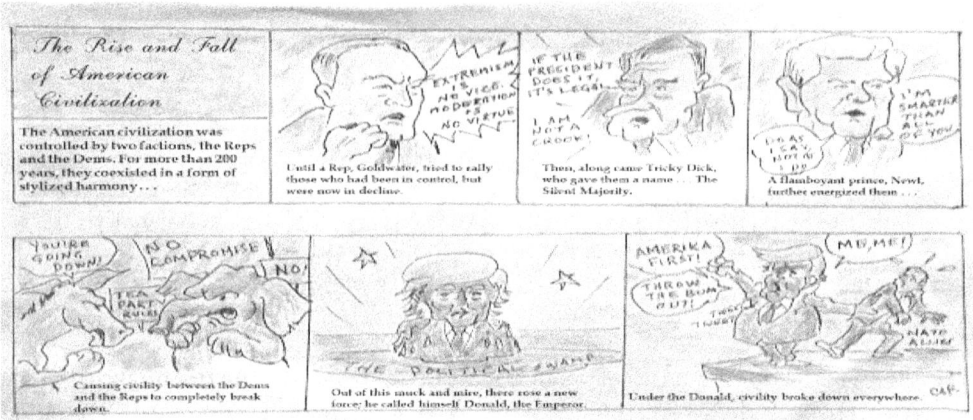

My reaction to the president's lack of civility and common courtesy when dealing with people.

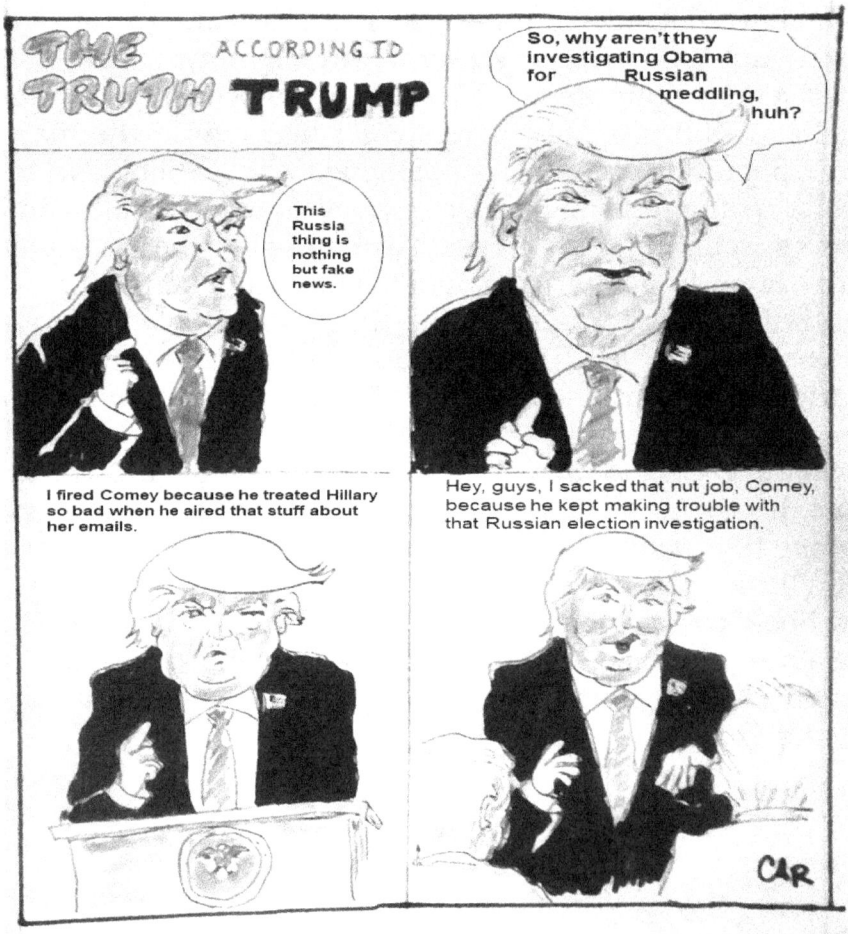

Trump's many versions of why he fired FBI Director James Comey have a decidedly fishy smell to them.

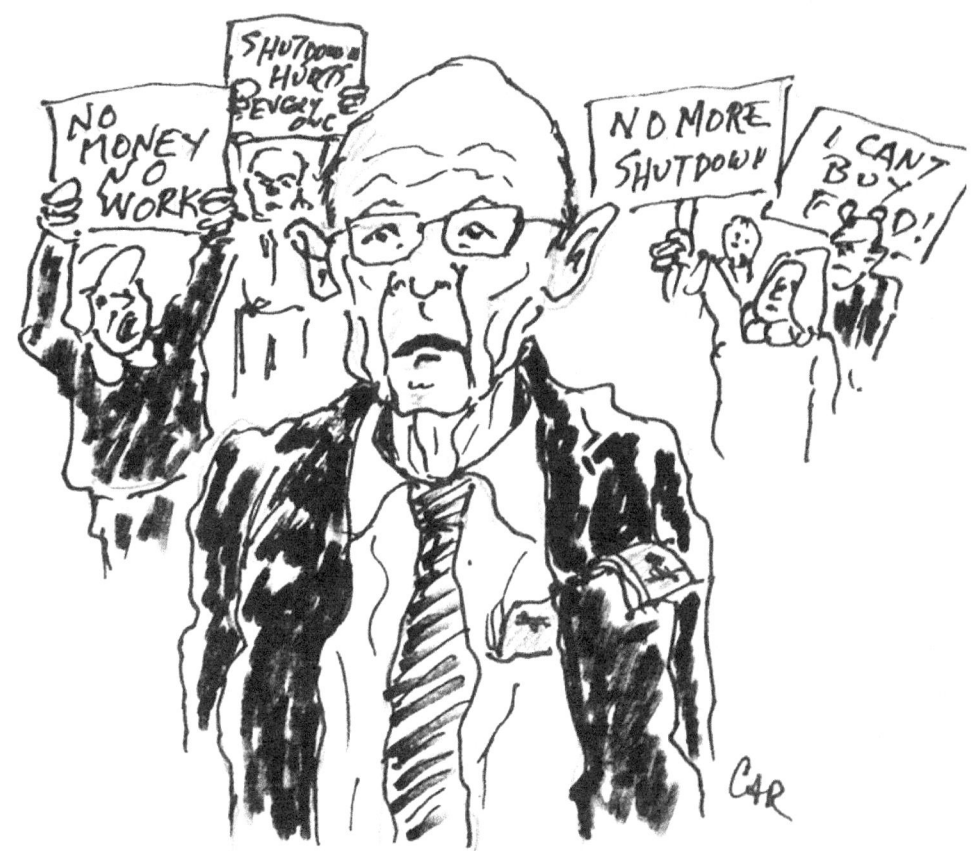

"I don't really quite understand the problem."

Commerce Secretary Wilbur Ross's tone deaf, insulting comment about furloughed government employees having to go to food kitchens during the 2018-2019 partial government shutdown.

My reactions to the Trump phenomenon were not always expressed in art. The morning after the election, for example, I penned a blog post, sort of forecasting what I saw lying ahead. Looking back, I realize that I was pretty darned accurate. Check out the following, 'The World Didn't End, But It'll Never Be the Same:'

I went to bed last night before the results were in, but it wasn't looking good. When I woke up this morning, my worst fears had been realized. The American electorate took leave of its senses and elected a failed businessman, con man, reality TV personality, misogynist, bully as president.

Now, while I am not at all pleased at the outcome of this election, unlike the designated winner, I'm willing to accept the expressed will of the voters even if the candidate I supported didn't win. That's what American democracy is supposed to be about. Rather than bemoan the results or whine about a 'rigged' election, I'll just say I hope Mr. Trump is as savvy a businessman as he claims to be and will figure out that the bombast that got him the job is totally inappropriate once he's actually *in* the job.

You see, now the real job begins. There's the matter of staffing the administration. One can only wonder what caliber and quality of individual will step forward to serve in senior leadership positions in a Trump administration. Bullies tend to attract bullies, and I can think of a few that I worked with when I was an appointee in the George W. Bush administration who will be at the front of the line—and, heaven help the country under their stewardship. The wrong people in one or two key positions can create a lot of havoc over a four-year period.

Next is the question of how Trump will address the issues he stressed during a down and dirty campaign that appealed to the anger and frustration of a demographic of people who, angry at the 'establishment' for letting them down, decided to express that anger and frustration by electing him. They'll be expecting him to address their frustrations. But, globalization and the inexorable march of technology is at the root of a lot of their problems, along with the apathy of citizens (themselves included) who sit and wait for someone else to solve their problems. I can't think of a thing any president can really do in the short term to address these problems, and we know that Americans are not long-term thinkers. I predict that many of the core Trump supporters will be pissed at him before the first year of his administration is out.

That's the big issue, but there are also the specific issues he hammered home again and again, issues that he'll have to address in one way or another or his credibility will go down the drain in a big swirl of toilet water.

- The Wall. A logistical and political nightmare, if not an outright impossibility, the wall between the US and Mexico (which he'll make the Mexicans pay for) is going to come back to bite him in the ass if he doesn't figure out a way to put it to sleep.
- A ban on Muslims entering the country. A policy that raises constitutional and legal questions in addition to the foreign policy imbroglio trying to implement such a ridiculous policy would unleash.
- Bombing the shit out of ISIS. A little shorthand there. He also said he'd support bombing members of their families and using any methods (read torture) to extract information. The military and intelligence community has already taken a beating on these issues, and I don't think they want to go back into that barn.

- Make NATO countries pay more. Again, a little shorthand. As usual, he took a valid issue and wrapped it in bullying bombast. The bottom line is, we need our NATO allies as much as they need us, so using harsh, 'my way or the highway' language with them is just plain stupid.
- His relationship with Russia and Putin. A lot of questions here that need answers. One can only hope the mainstream media pulls its head out of rectal defilade and digs into it.
- Putting Hillary Clinton in jail. Sounding like a third world dictator, Trump averred that if he was elected, he would prosecute Clinton for unspecified crimes. This is a no-win issue that he might be better off keeping his mouth shut about.
- Working with Congress. His party still controls both houses of Congress, but during the campaign, he slammed them as much as he did the Democrats. Now, he has to figure out a way to work with them across a broad range of issues. I predict it'll be like watching a pack of hyenas fighting over a wildebeest's carcass.
- His own legal and credibility issues. The 'grab them by the p***y tape,' allegations of rape and sexual assault, the Trump University legal suit, and the many times he's been proven to have lied. If he or any in his camp think these issues will go away now that the election is over, they are in for a hu-u-u-uge surprise.

Watching Washington over the next four years promises to be interesting. Presidents are a target for comedians, caricaturists, and op-ed writers, and their every fault will be chronicled across the globe. A president has to have a thick skin and be able to roll with the punches. The American voter has just elected a man with a very thin skin who doesn't take at all well to being attacked. In a perverse way, this will be fun to watch.

Okay, I missed it on a couple. For example, I didn't predict the Dem sweep of the House in the 2018 mid-terms, but he *did* have a hard time working with congress even when the GOP controlled both houses. For example, his own party refused to give him the wall money he demands, and which he used as an excuse for the partial government shutdown in December 2018, which, despite having said earlier in the month that he'd be 'proud to shut the government down, and would take full credit for,' he tried to blame on the Democrats. On the other issues, though, I think you'll agree that I got them close enough.

Charles Ray

FIRST, TRUMP CAME TO THE PARTY, THEN THE PARTY CAME TO TRUMP

Watching Donald Trump mesmerize the Republican Party, if it didn't have such dire implications, would be highly entertaining. It went from the GOP viewing him with attitudes of dismissal and disdain to, when they realized that he had a lock on their core base—the Rust Belt folks who were feeling the need of a little love from the 'gubmint.' The disdain, as Trump knocked one after another GOP presidential hopeful on his keister, turned to devotion, and now you have Republican notables like SC Senator Lindsey Graham, a fierce critic during the campaign, bending over backwards to explain Trump's gaffes and misdeeds (the partial exception being Graham's reaction to Trump's inexplicable decision to pull US troops out of Syria), and GOP senate leader, Kentucky's Mitch McConnell, all but surrendering his leadership gavel to Trump, especially after the Democrats seized control of the House of Representatives in the 2018 mid-term elections.

Like the Pied Piper, Trump plays his merry tunes and watches the GOP dance its discordant jig, and the ship of state continues to sail aimlessly through an increasingly turbulent sea.

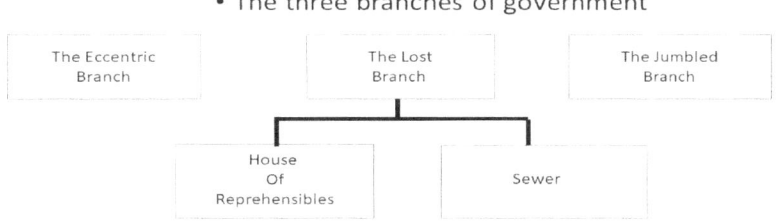

My take on the government organization chart under the reign of Emperor Donald. (A kakistocracy, by the way, is the rule of the dumbest)

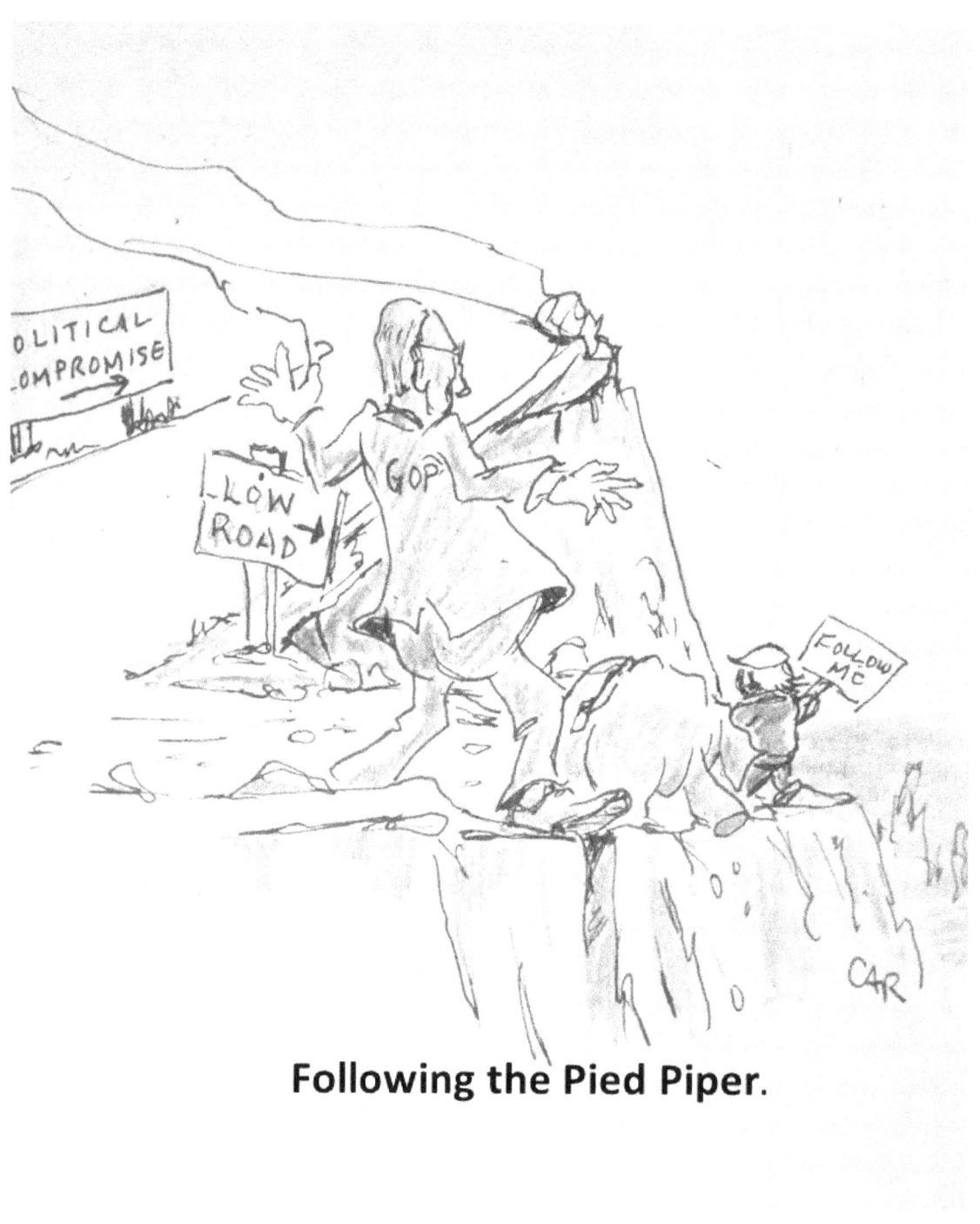

Following the Pied Piper.

From disdain to devotion, the GOP now blindly follows the Pied Piper of Trumpland.

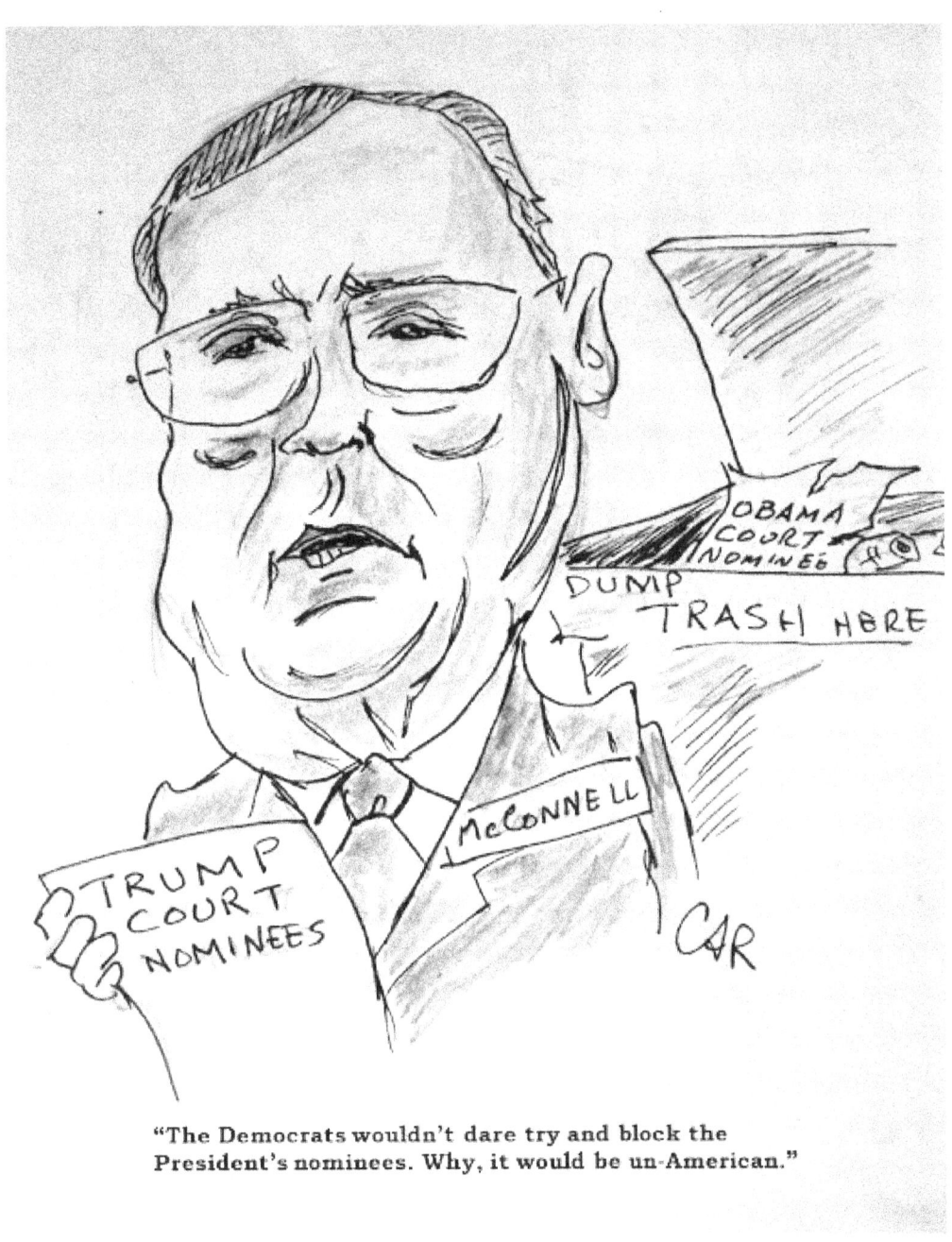

"The Democrats wouldn't dare try and block the President's nominees. Why, it would be un-American."

It's really funny how Senate GOP leader Mitch McConnell went from a Trump basher to rolling over to Trump's every demand on most issues. And, the hypocrisy of the man is astounding, absolutely astounding.

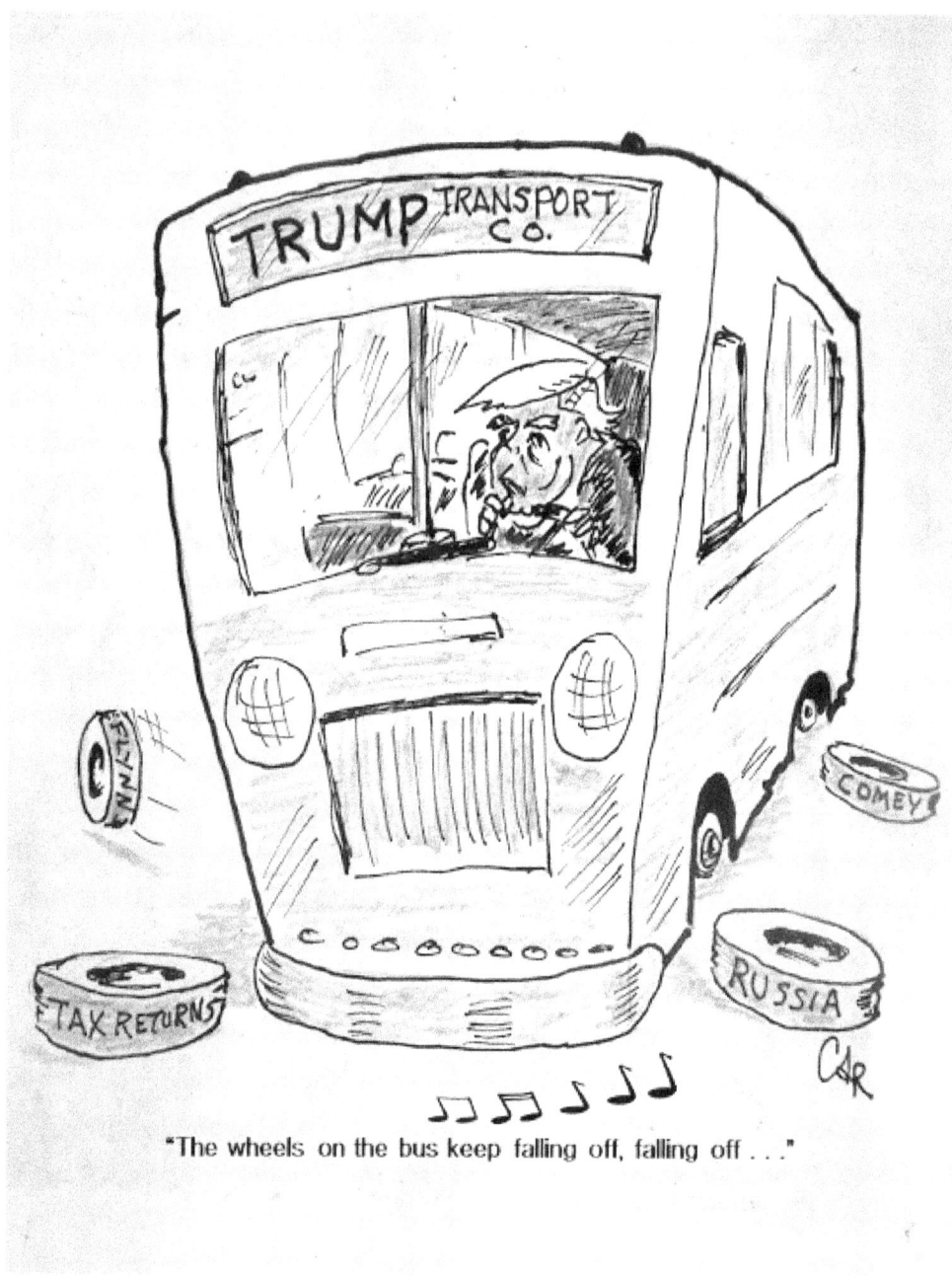

"The wheels on the bus keep falling off, falling off . . ."

Even when it looks like the wheels are coming off the Trump mobile, Republicans, fearful of the wrath of their base, continue to cover for, enable, and blindly follow Trump down every rabbit hole, forgiving him transgressions they would've organized a lynch mob if his predecessor had done the same.

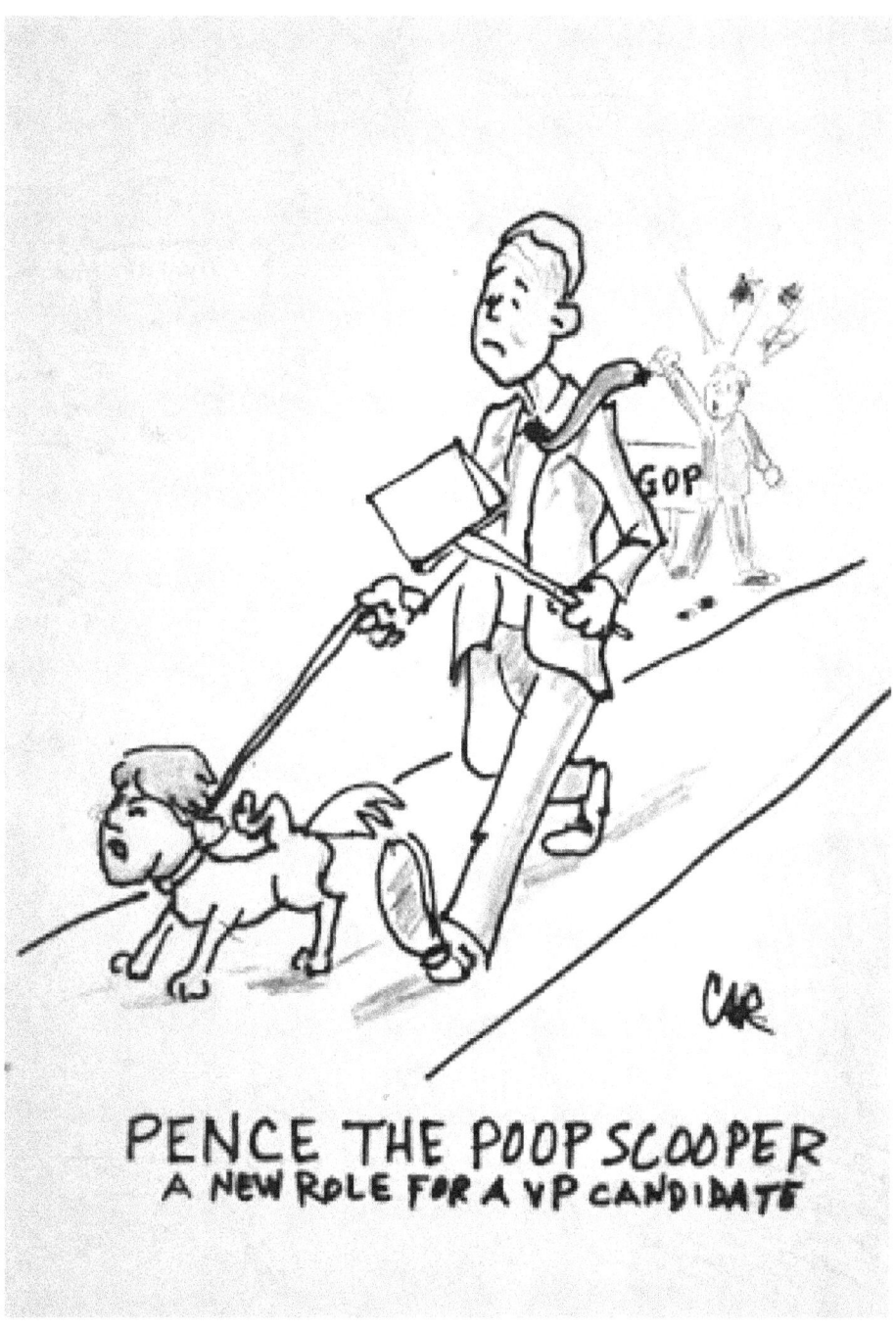

I was surprised at first when VP candidate Mike Pence was pressed into service as the one to go around to other Republicans and apologize for Trump's insults and jabs, then they got elected and I realized that this is his calling.

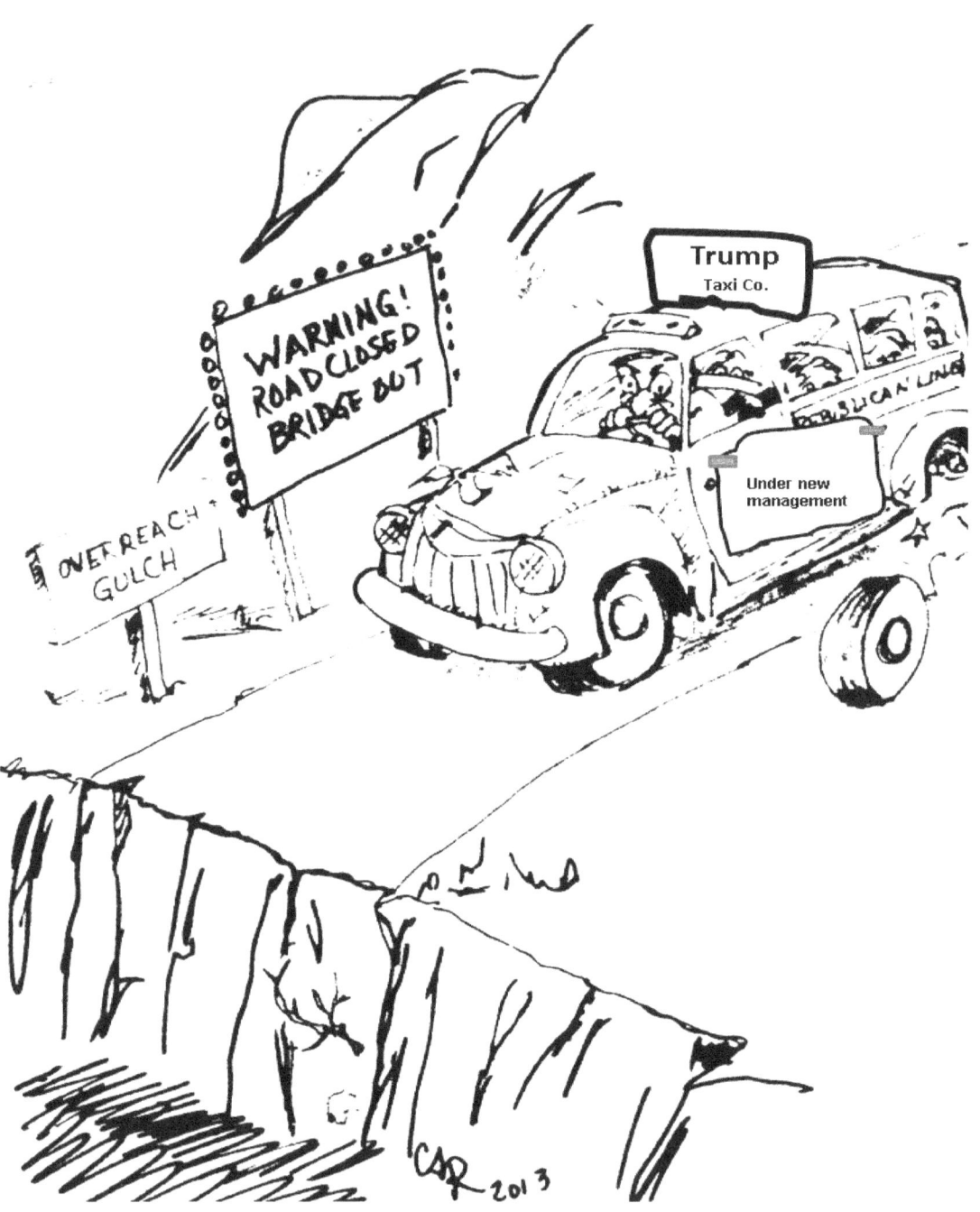

The GOP have turned the wheel over to a new driver, and now they can either bail, hang on for the ride, or take it back. It's as hard to tell what they might do as it is to tell what Trump's thinking from hour to hour.

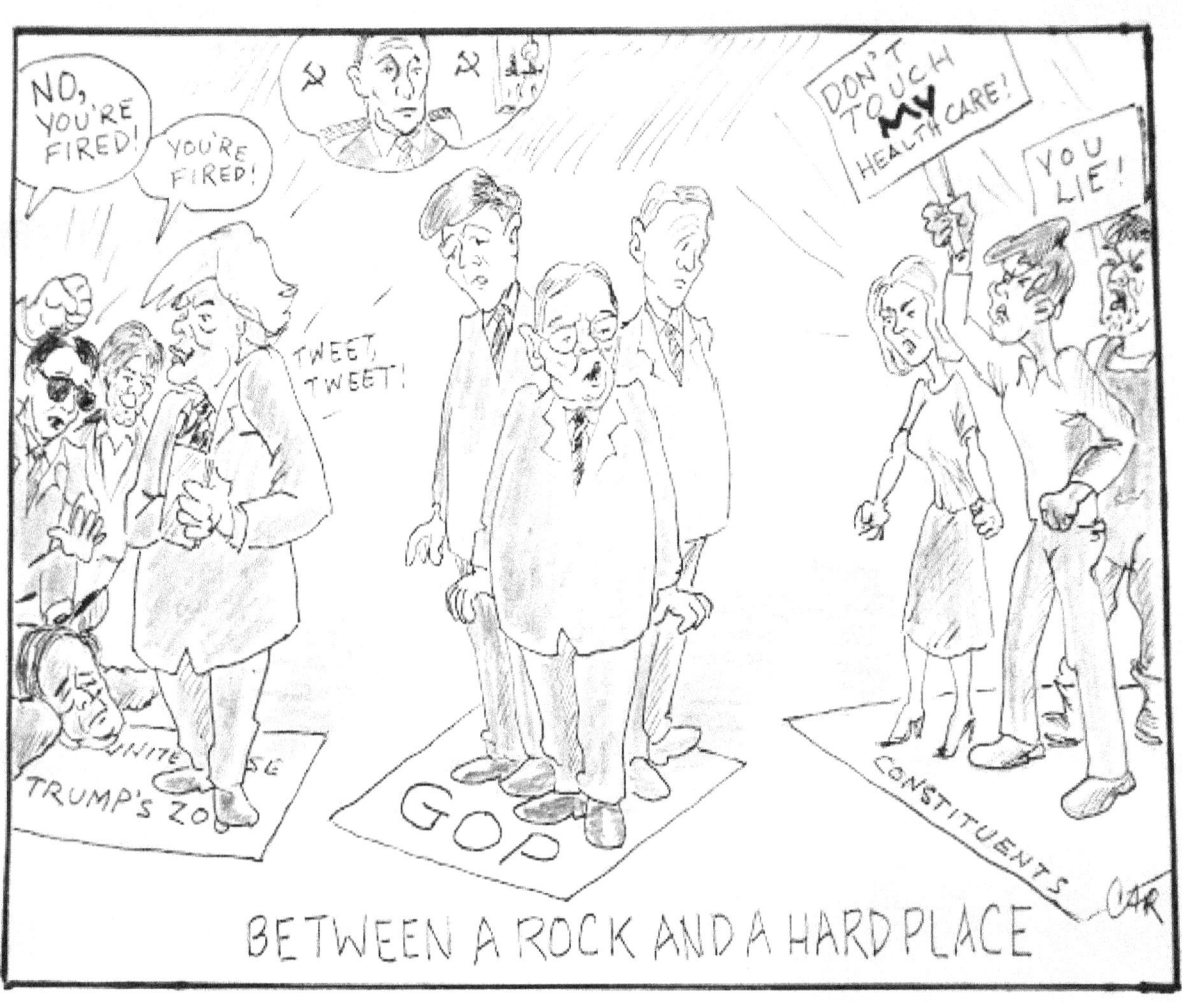

And, things aren't getting any better.

Charles Ray

TRUMP'S RELATIONSHIP WITH THE TRUTH

Political candidates exaggerate when campaigning; it's not something that impresses me, but I know it happens, and tend to ignore it. After Donald Trump was elected, though, one would have hoped he would switch from campaign mode to governing, which requires a modicum of honesty. Not happening. According to the *Washington Post* Fact Checker, a site that keeps a running total of Trump's false and misleading claims since he was inaugurated, as of January 20, 2019, he had made 8,158 false or misleading claims, for an average of approximately 11 lies or misrepresentations for each day of his presidency. He has told some lies so many times, for example his continued linking of his border wall with drug trafficking when his own Department of Homeland Security states that the vast majority of drugs come through ports of entry rather than over the desert, that his hard-core supporters believe it. If you don't believe me, post on Facebook that the wall won't stop drugs, and within minutes you'll be deluged with Trump trolls informing you that you're wrong, wrong, wrong.

If Trump was Pinocchio, his nose would enter the next state hours before his body. Okay, that's an exaggeration of Trumpian proportions, but you get the picture. The man just can't seem to help lying. Here's a classic example. When his intelligence chiefs testified before congress on national security threats in January, 2019, and in their testimony contradicted Trump's public assertions about North Korea, ISIS, Russia, and a few other things, he chastised them and suggested they 'go back to school.' Later, he said they'd been misquoted and taken out of context by the 'fake news,' and that they now agreed with him. The problem with that: they were filmed making statements from written notes, and we don't have any of them publicly saying what Trump claims they said. Instead, we have a photo of them sitting in his office looking like they're getting a tongue lashing from the vice principal for misbehaving, followed by his tweets and statements with *his* version of reality.

It didn't take me long to figure out how to know when he's lying; whenever his lips are moving.

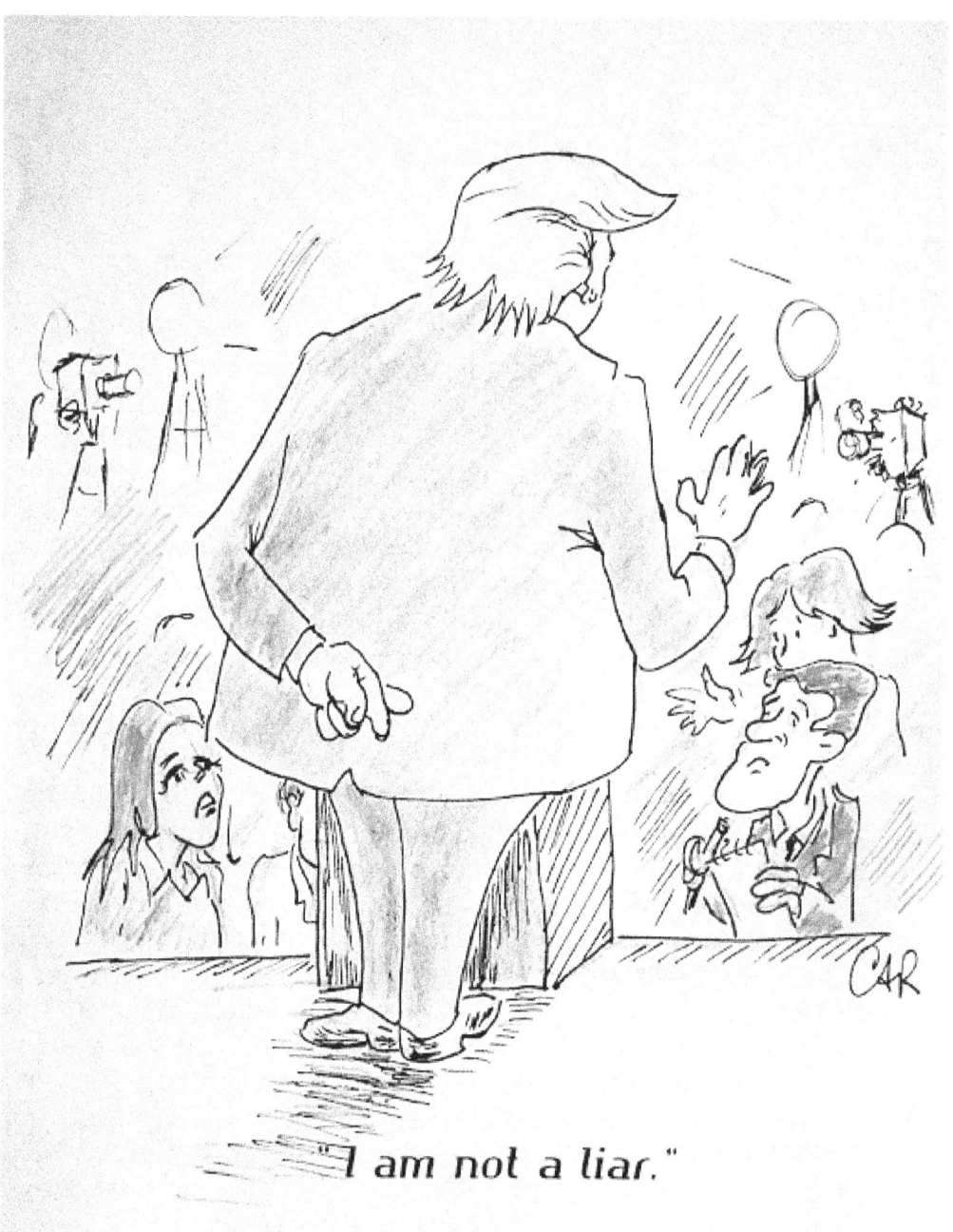

Remember Nixon saying 'I am not a crook,' shortly before he had to resign to avoid impeachment?

Invasion of the Swamp Creatures

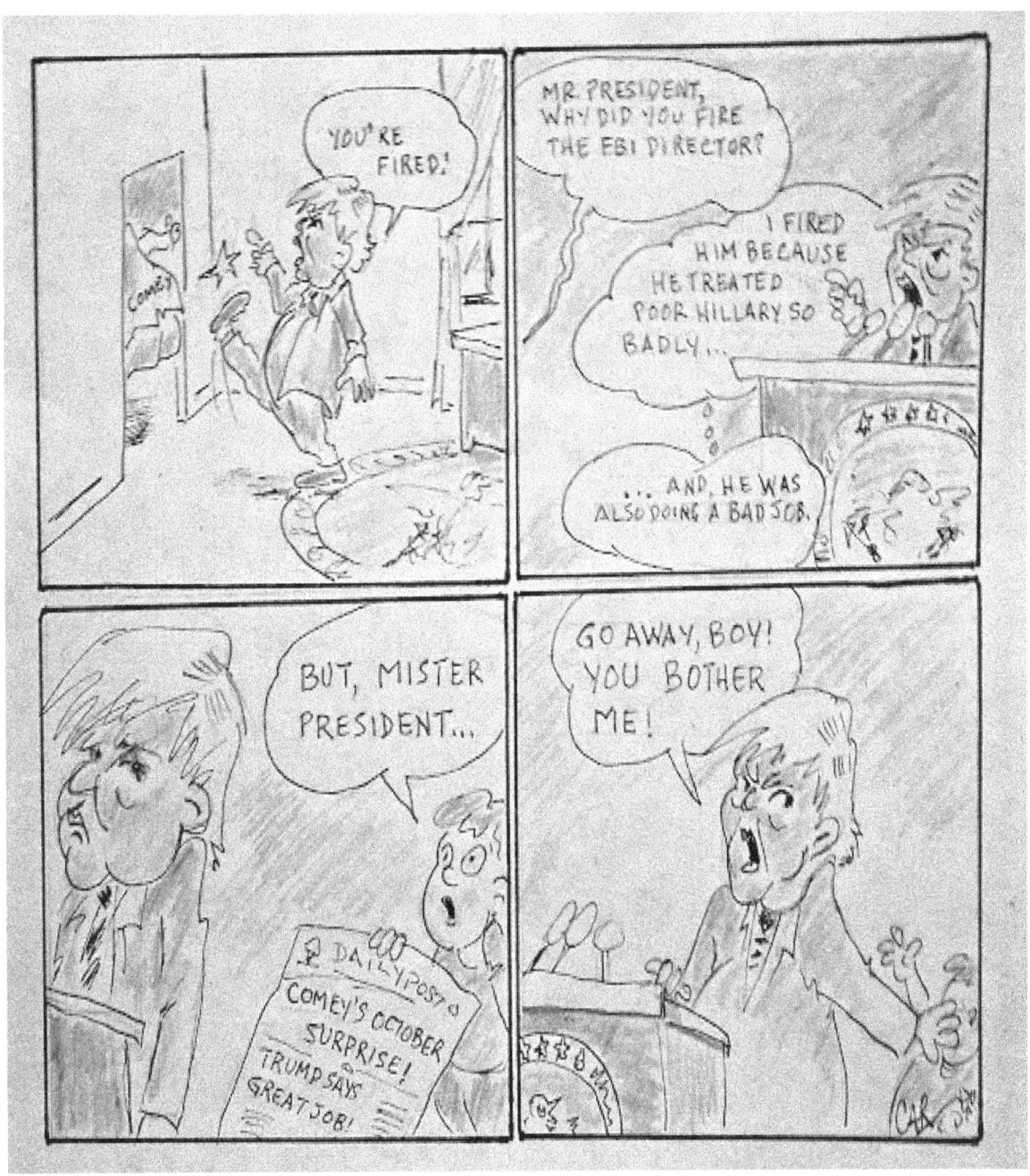

 I'm still not absolutely clear about the firing of FBI Director Comey, other than Trump really, really didn't like that troublesome Russia investigation.

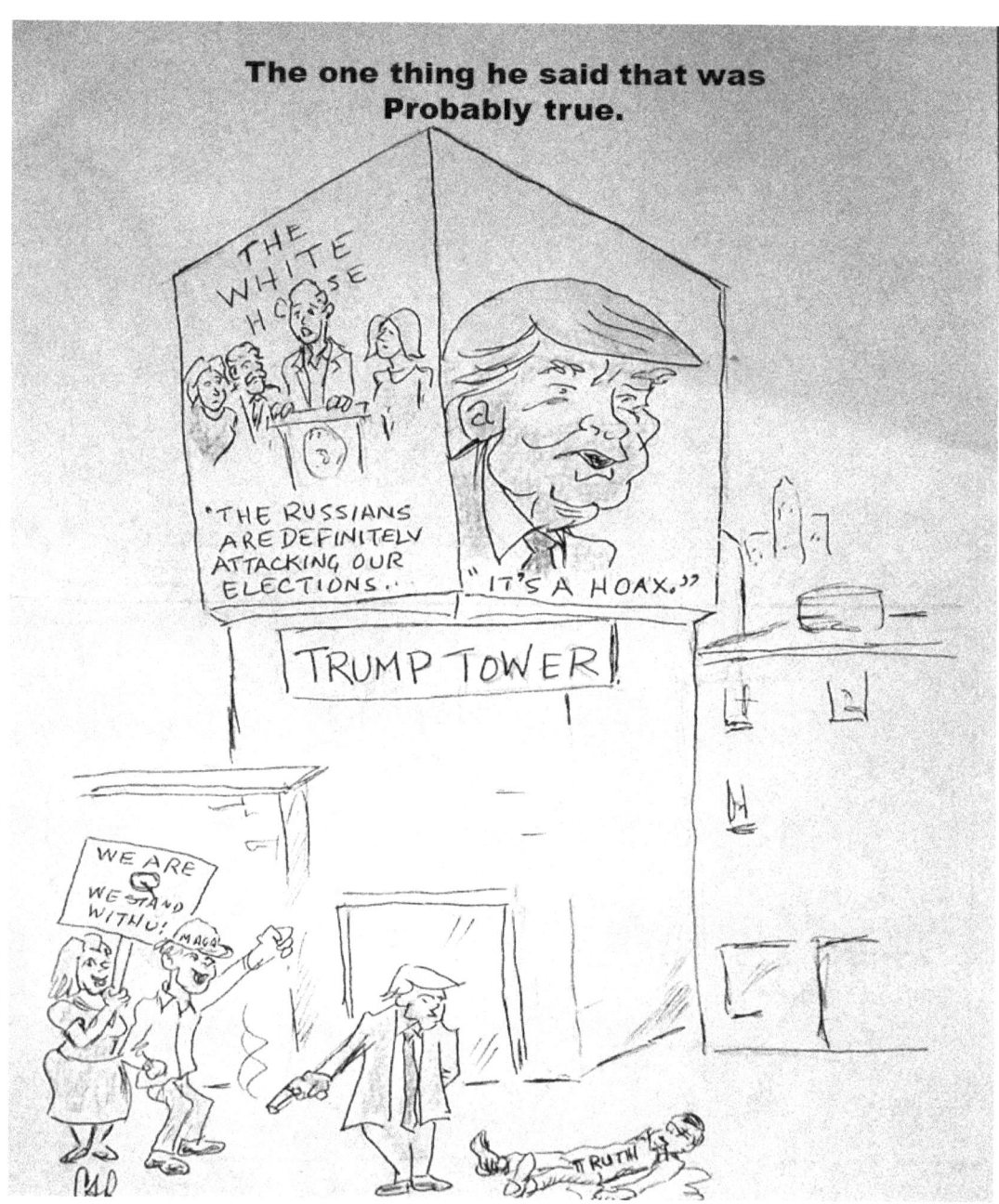

Given the maniacal support from his base, the 'shoot someone on Fifth Avenue' claim is probably the most truthful thing he's ever said.

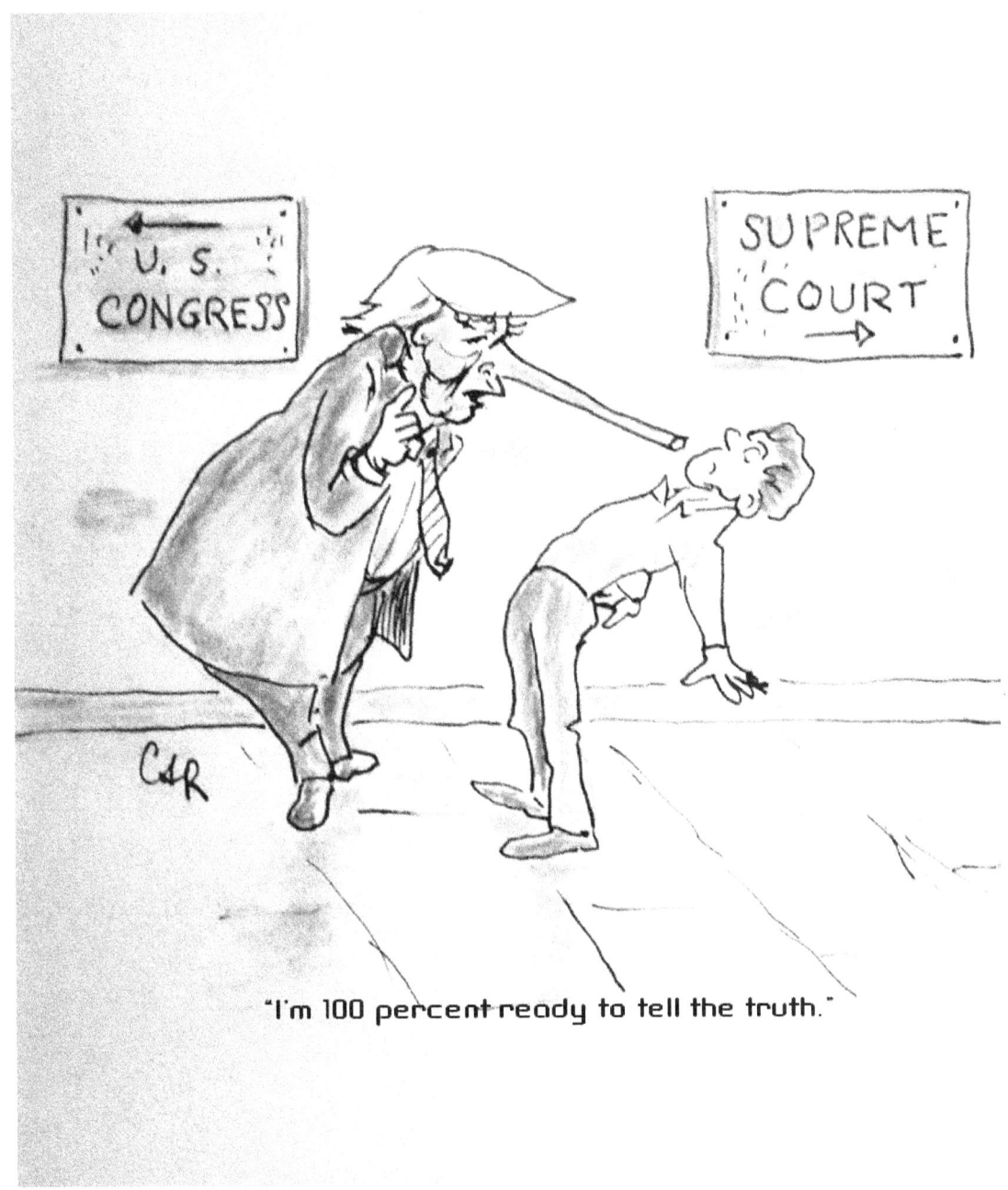

That nose just keeps getting longer and longer.

Charles Ray

TRUMP AND INTERNATIONAL RELATIONS: EXCEPT FOR THE PUTIN BROMANCE, A BULL IN A CHINA SHOP

As if domestic turmoil, including the longest partial government shutdown in the nation's history, was not enough, Donald Trump has stomped, bellowed, elbowed, and insulted his way around the globe—sometimes without even leaving Washington, DC. He has insulted Canada, the UK, and Australia, our closest allies, thrown darts at NATO and the EU, and Germany in particular, blindsided our South Korean and Japanese allies, and started a trade war with China—not, mind you, that China doesn't need a little reform, it's just that Trump's scorched earth style of trade negotiations hurts the US more often and more severely sometimes than it does the Chinese. Don't believe me? Talk to soybean farmers in the Midwest. It's been reported that he referred to countries in Africa, and other places with significant nonwhite populations, as shithole countries, and a preference for immigrants from places like Norway.

The exception to his apparent dislike of nonwhite foreigners is North Korea. He has publicly praised North Korea's murderous dictator, Kim Jong-un, calling him a young man who has 'strong' control over his country. I guess if you use cannons or anti-aircraft guns to execute your opponents, you too would have pretty good control. Despite intelligence information indicating that Kim has no plans to give up his nukes, Trump continues to claim that he has made a 'deal' with the young dictator.

The only tyrants he seems to dislike are the ones in Iran and Venezuela, and that might be because they don't flatter him.

The relationship, though, that is the strangest, and maybe even the most dangerous, is his bromance with Russian strongman Vladimir Putin. Everyone with an ounce of brain knows that the Russians meddled in the 2016 elections on Trump's behalf, but mainly against Hillary Clinton, who they feared and hated, but Trump refuses to come right out and say it, and has publicly disagreed with his intelligence chiefs on the matter. He often spouts lines that sound as if they were written by Kremlin spin masters, such as the outright lie that the Soviets went into Afghanistan to fight terrorists, when, in fact, they went in to prop up a failing communist regime.

The latest chapter in the 'Trumputin Show: The Adventures of Donny and Vlad,' is the announcement in early 2019 that the US is pulling out of the INF Treaty, the last arms control treaty between the US and Russia, followed quickly by Putin's announcement that the Russians were also pulling out. Coordinated actions? Probably not, but it sure feels hinky to me.

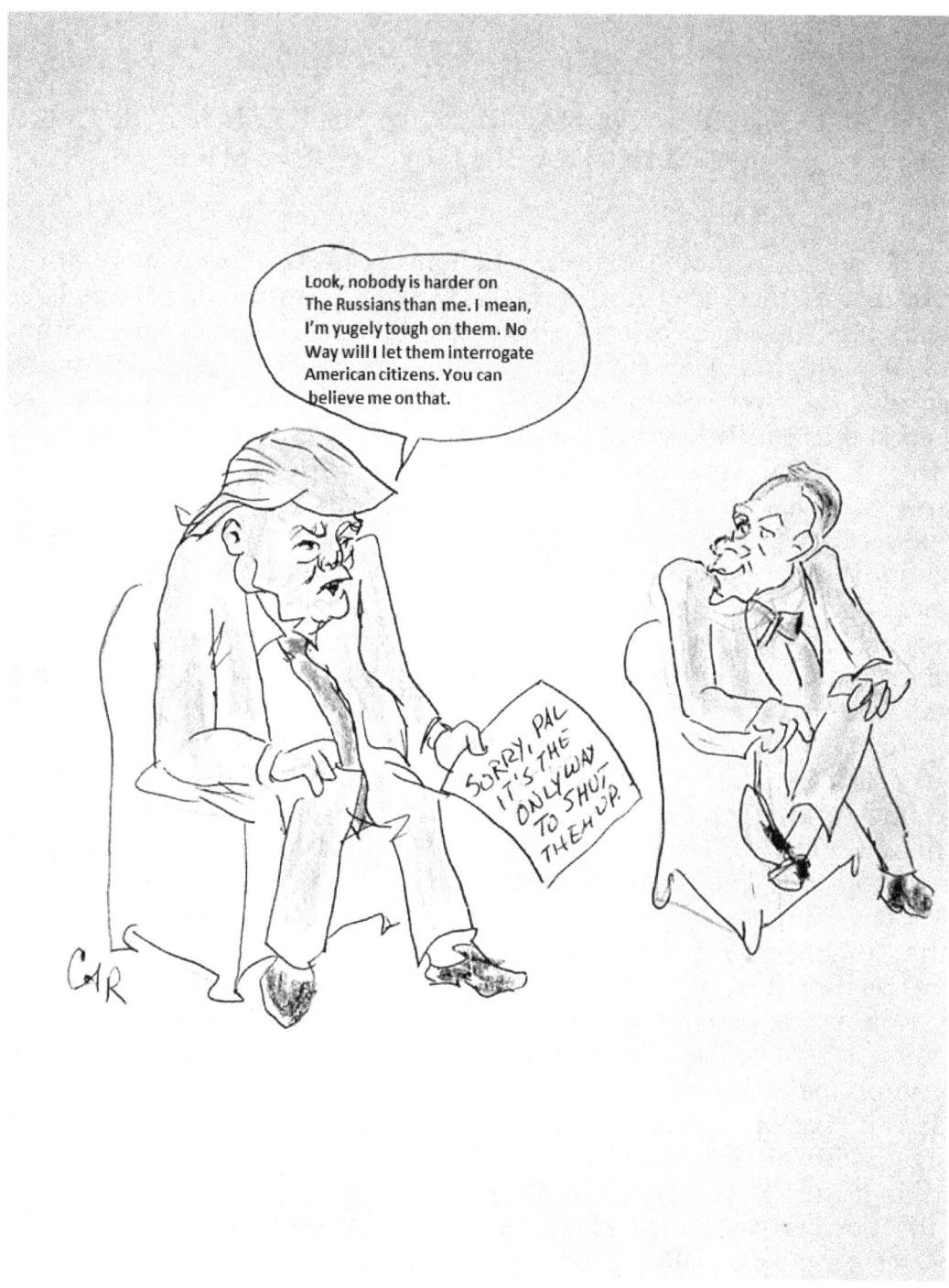

Trump claims to have been harder on Russia than any president before him, but his speech and actions when it comes to Russia, and Putin in particular, totally contradict that.

Invasion of the Swamp Creatures

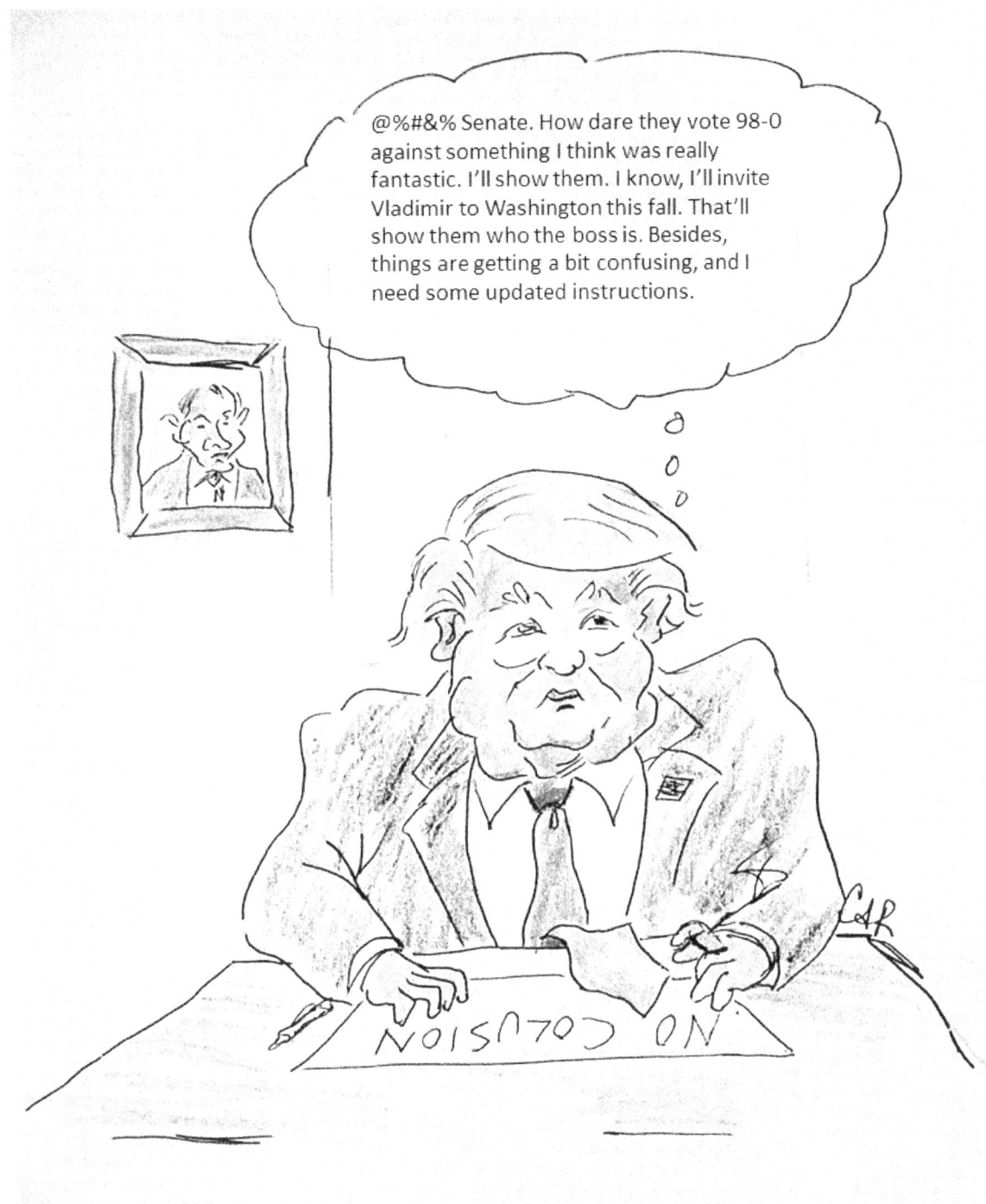

When it comes to Putin, Trump's behavior is inexplicable.

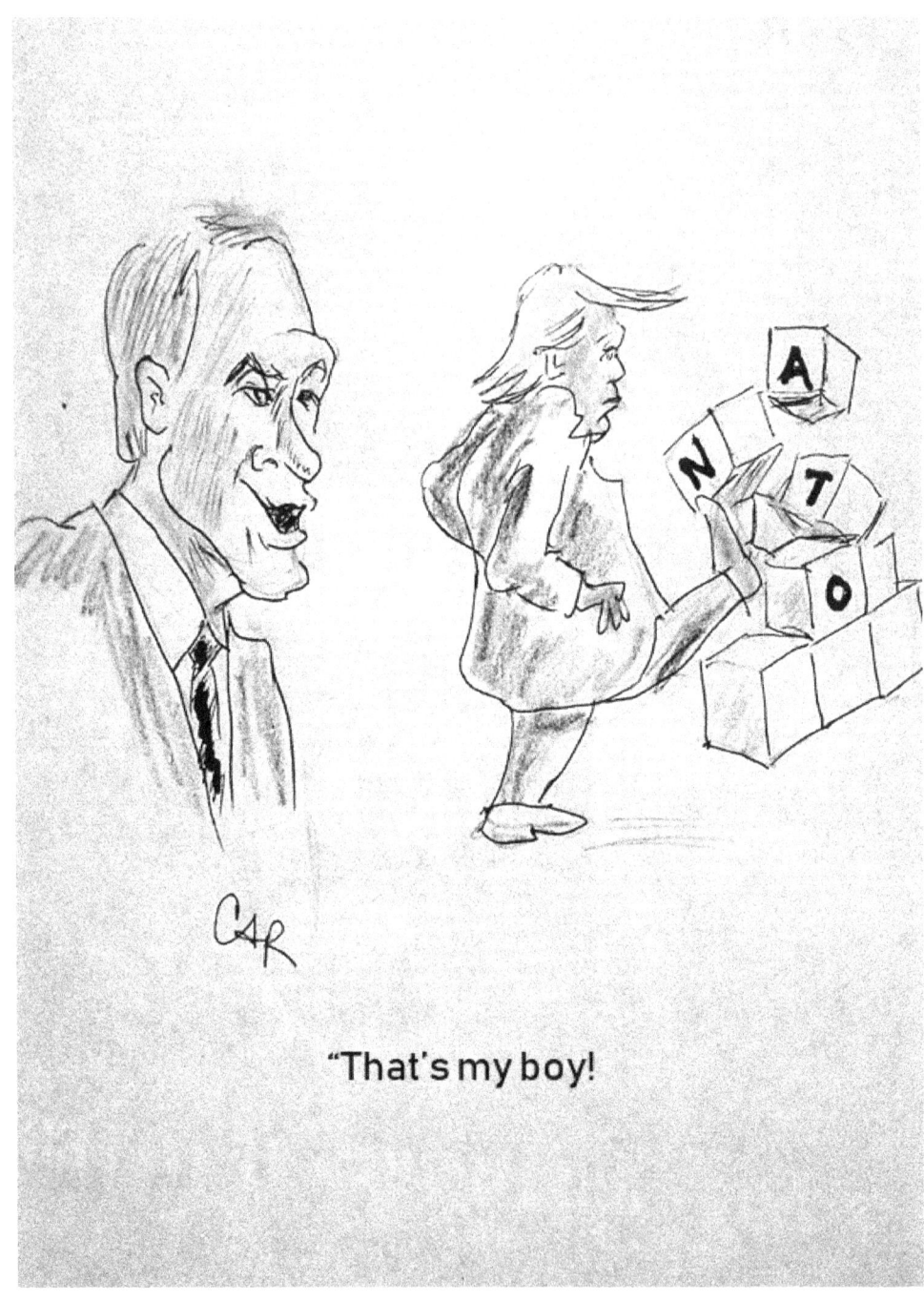

Trump's actions and statements on NATO come directly from Putin's playbook.

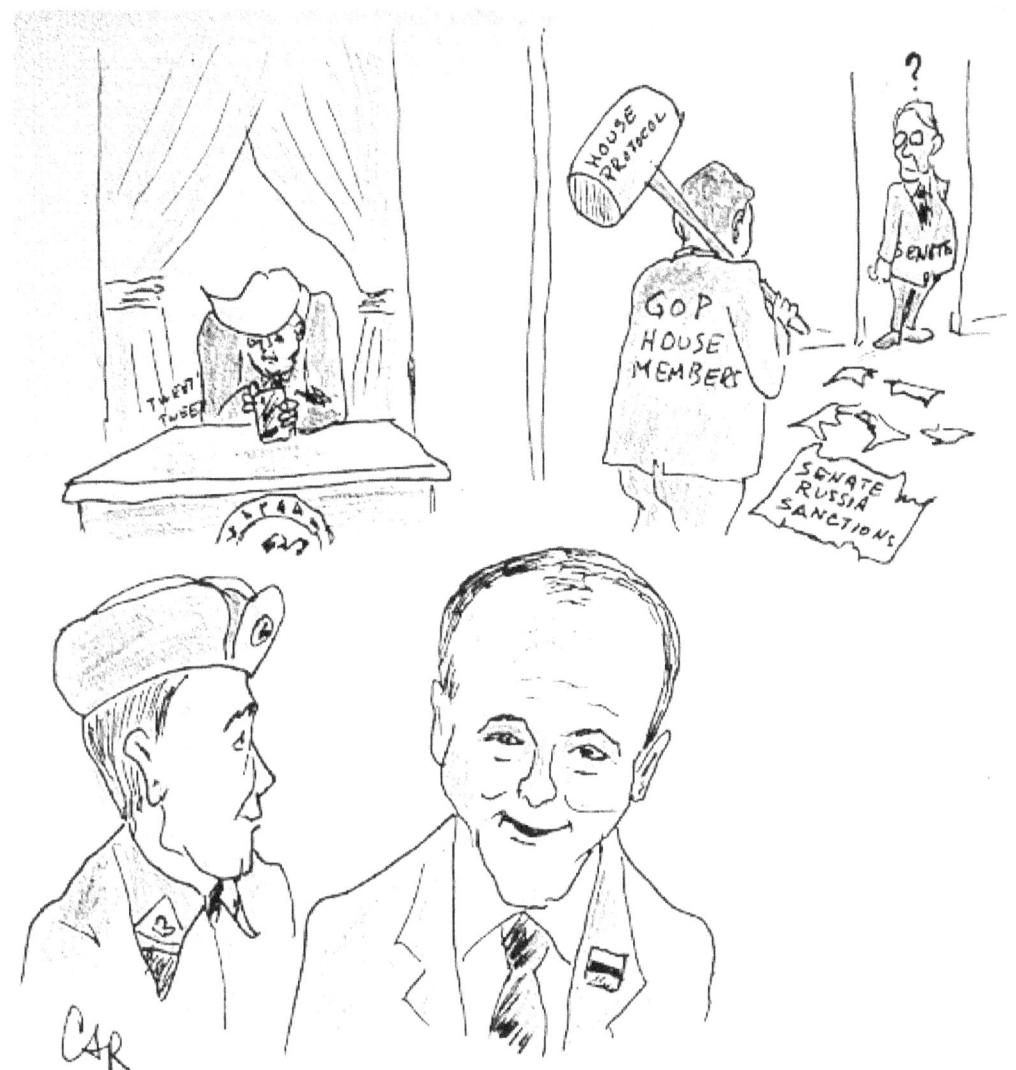

"Is not always necessary to play trump card to win hand."

Of course, the way certain members of the GOP acted, it wasn't always Trump who seemed to be in bed with Putin.

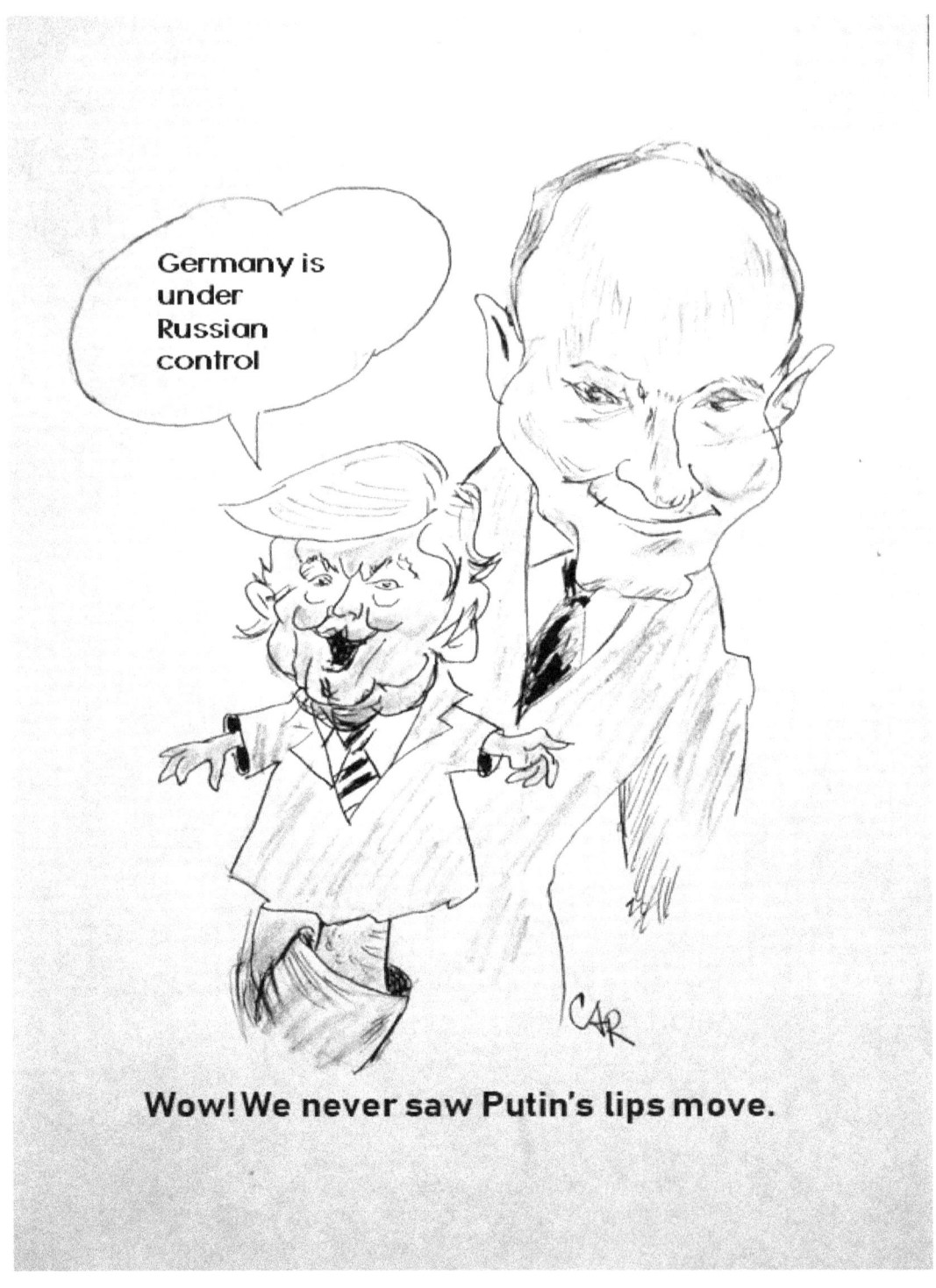

Of course, the Donald could always be depended upon to appear to be advancing Russia's interests.

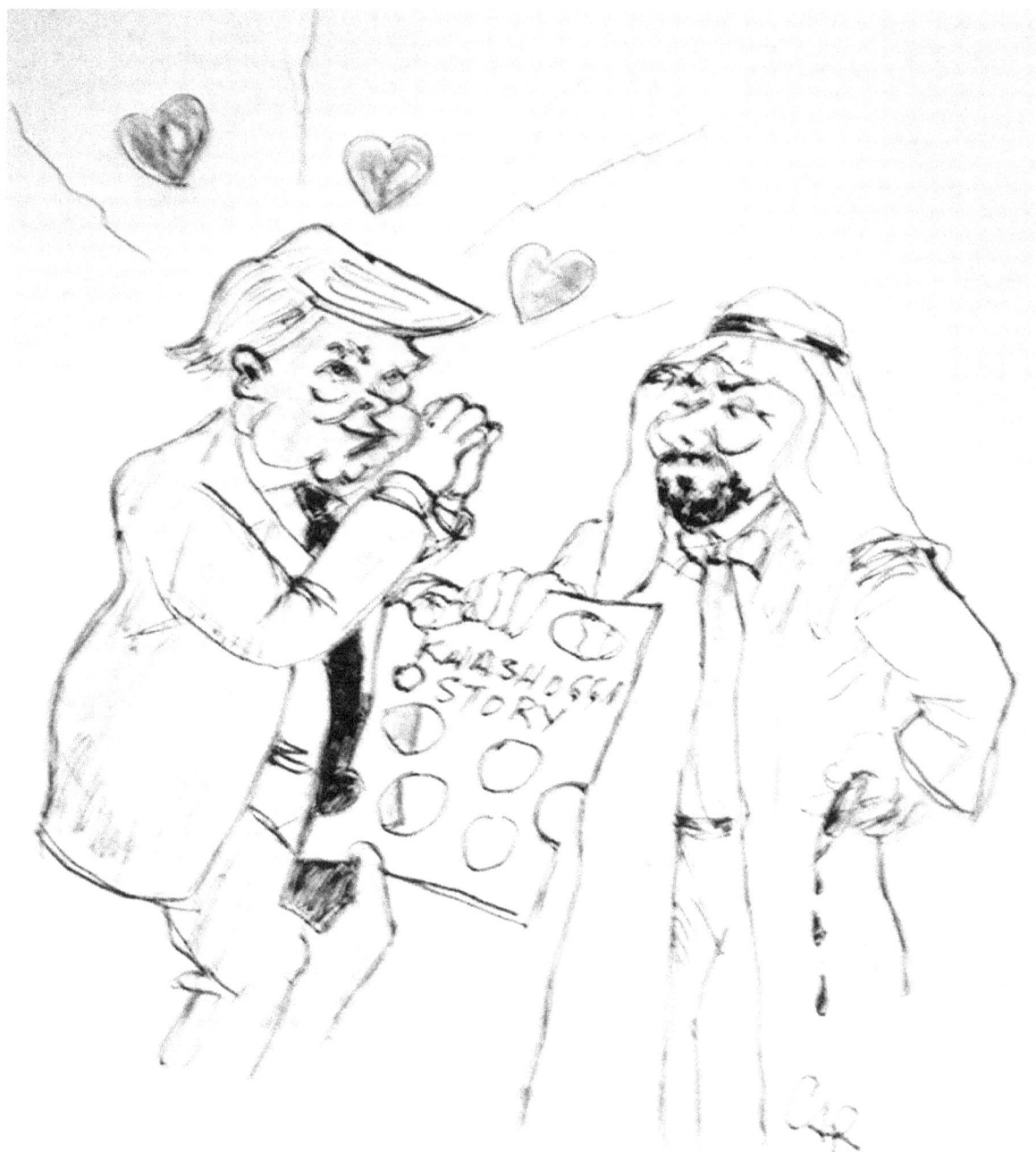

Hook, line, and stinker – a strange bromance.

Lest we forget, Putin, though the main act, is not the only strong man that Trump seems to have affection for.

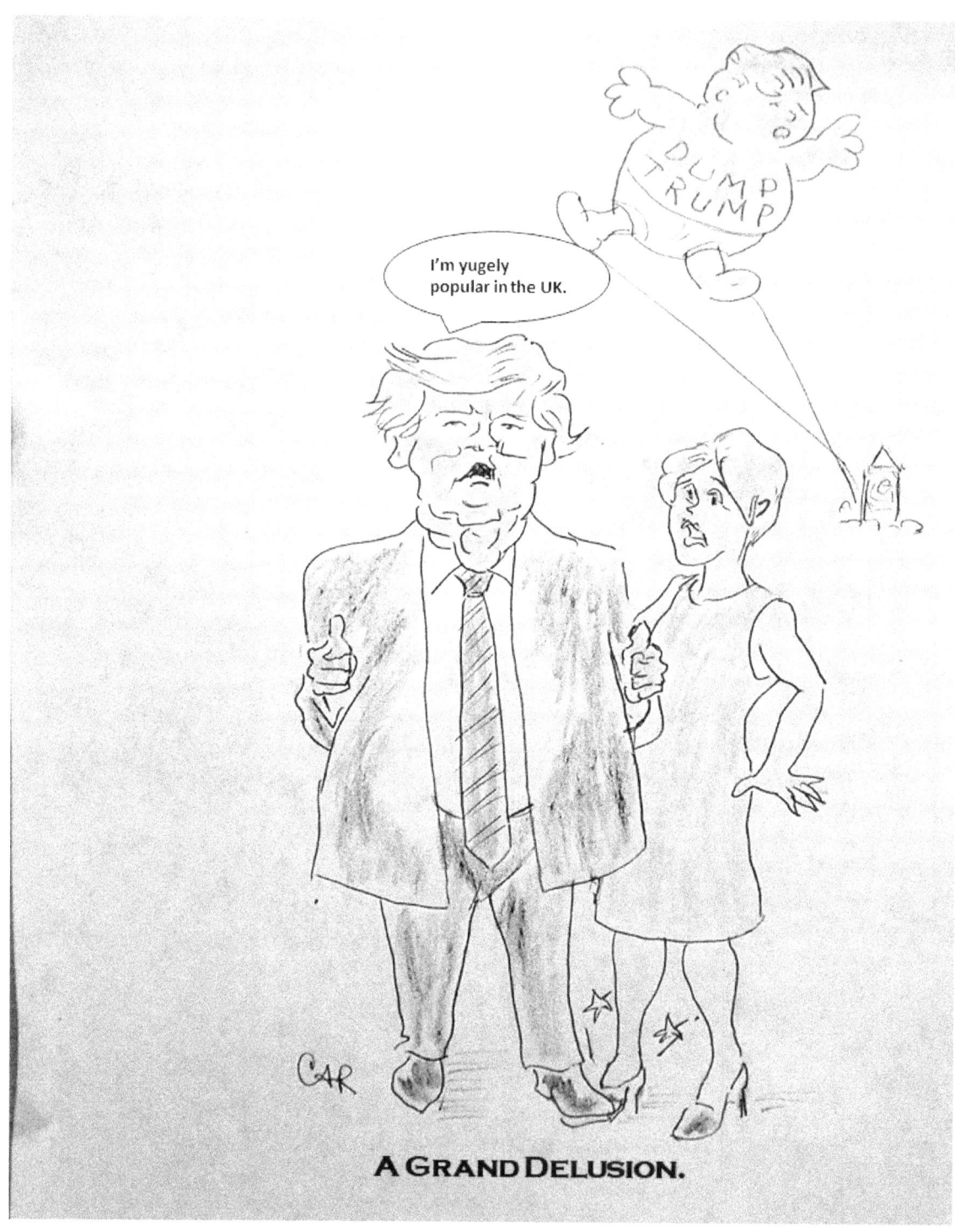

Like the alcoholic uncle who embarrasses everyone at family reunions and thinks he's funny, Trump steps on toes everywhere he goes.

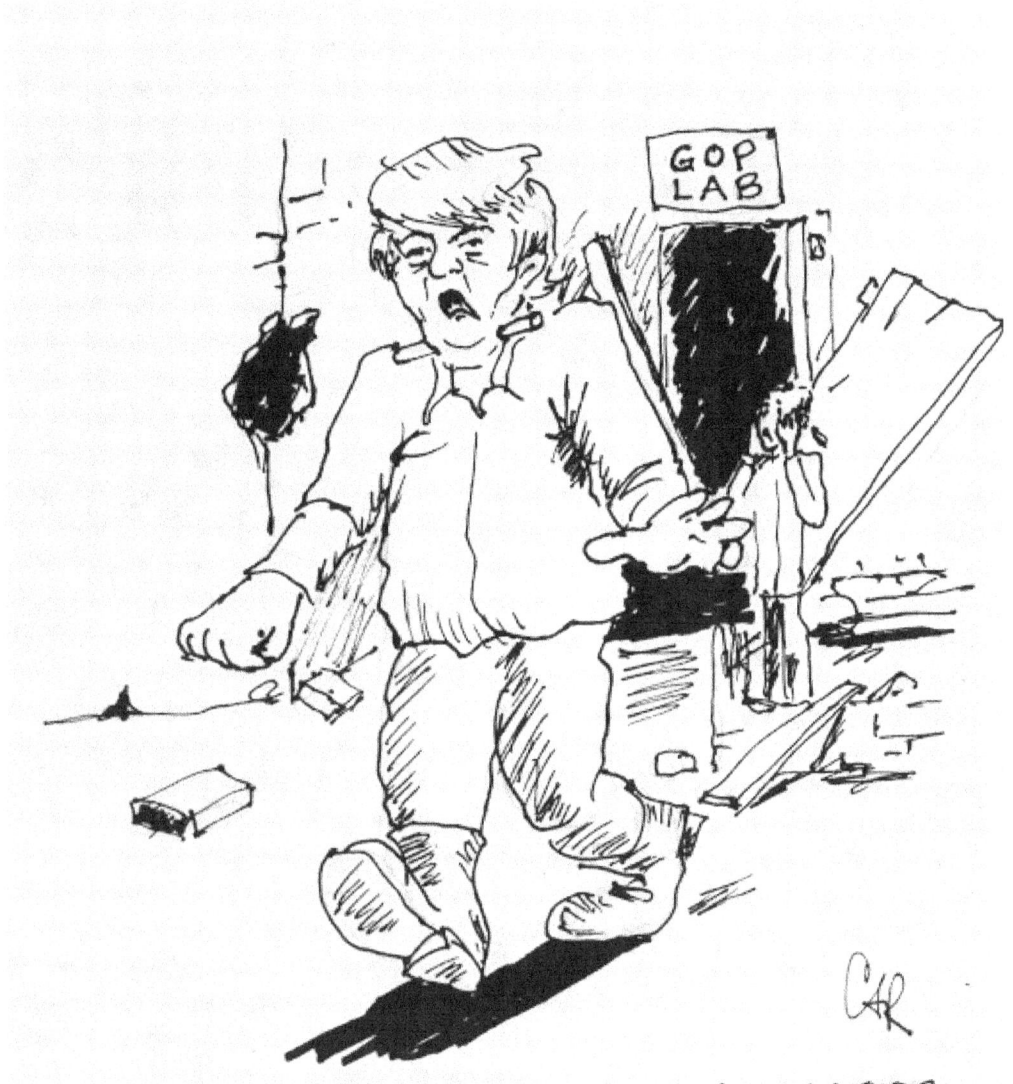

Every now and then, GOP politicians complain quietly about Trump's boorish behavior, and then, they don't do diddly squat about it.

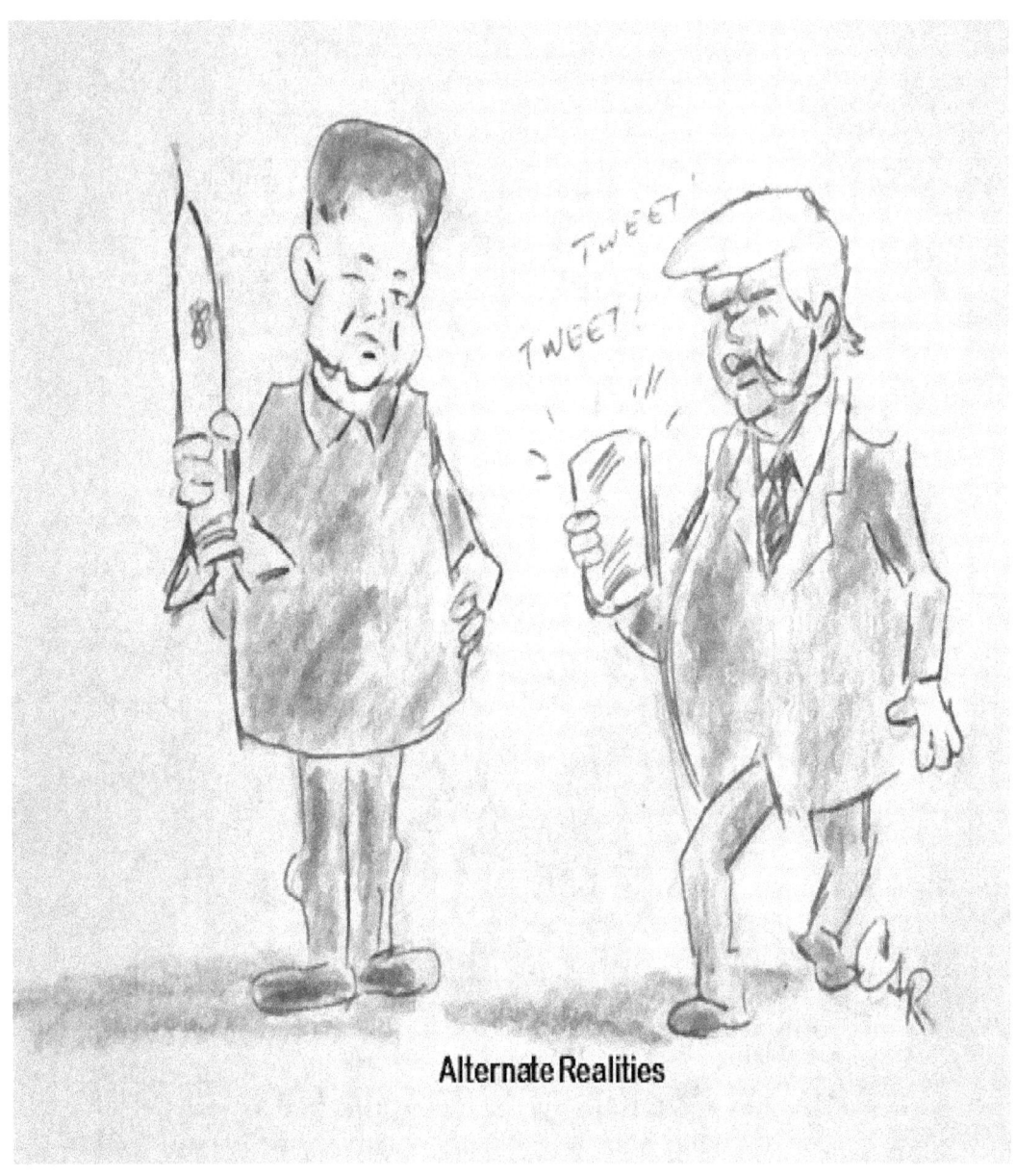

The war of words between Trump and North Korea's Kim Jong-un had everyone on edge for a while.

JUST THINK, WE'VE GOT TO ENDURE TWO MORE YEARS OF THIS!

The Trump Administration is at its halfway mark, and many people, myself included, are girding their loins to endure the next two. The new Democratic majority in the House of Representatives have a few people chomping at the bit to 'impeach the m-----f----r!', but with the GOP still controlling the Senate, that's an unlikely scenario. Besides, I'm not so sure we'd be any better off with a wooden-faced, hypocritically pious Mike Pence in the hot seat.

The question is whether or not we can survive either of them. Trump has claimed victory over ISIS in Syria—his intelligence chiefs disagree—progress in denuclearization of the Korean Peninsula—they again disagree—and still claims there is a drug and terror crisis on our southern border—no one in his or her right mind believes that. He still wants a big military parade, a Buck Rogers-style Space Force, and has pulled out of the last treaty that, even though it didn't keep the Russians from cheating, at least kept a bit of a cap on a potential nuclear arms race that will now include China, at a minimum.

He seems to think that shutting the government down and putting the livelihoods and families of thousands (hundreds of thousands, actually) of government workers at risk, is an acceptable way to force his will on a congress that is not completely under his control, no matter how much he wishes it were.

He continues to undermine confidence in an independent media, the courts, federal law enforcement, and the intelligence community, and to treat the military as if it was one of his construction crews, a toy he can play with when he's bored, or a weapon he can brandish when he feels personally threatened.

Looking at how he conducts himself, it's hard to determine if he's acting like a real estate developer or a reality TV performer, or some oddball combination of the two. Whatever it is, and no matter how much his hard-core supporters like it, it is *not* the way to run a country. For nations, there is no bankruptcy protection and you can't shoot a retake if a scene doesn't go quite the way you wanted.

So, hang onto your seats folks, and keep your arms and legs inside the vehicle. We're in for a wild ride.

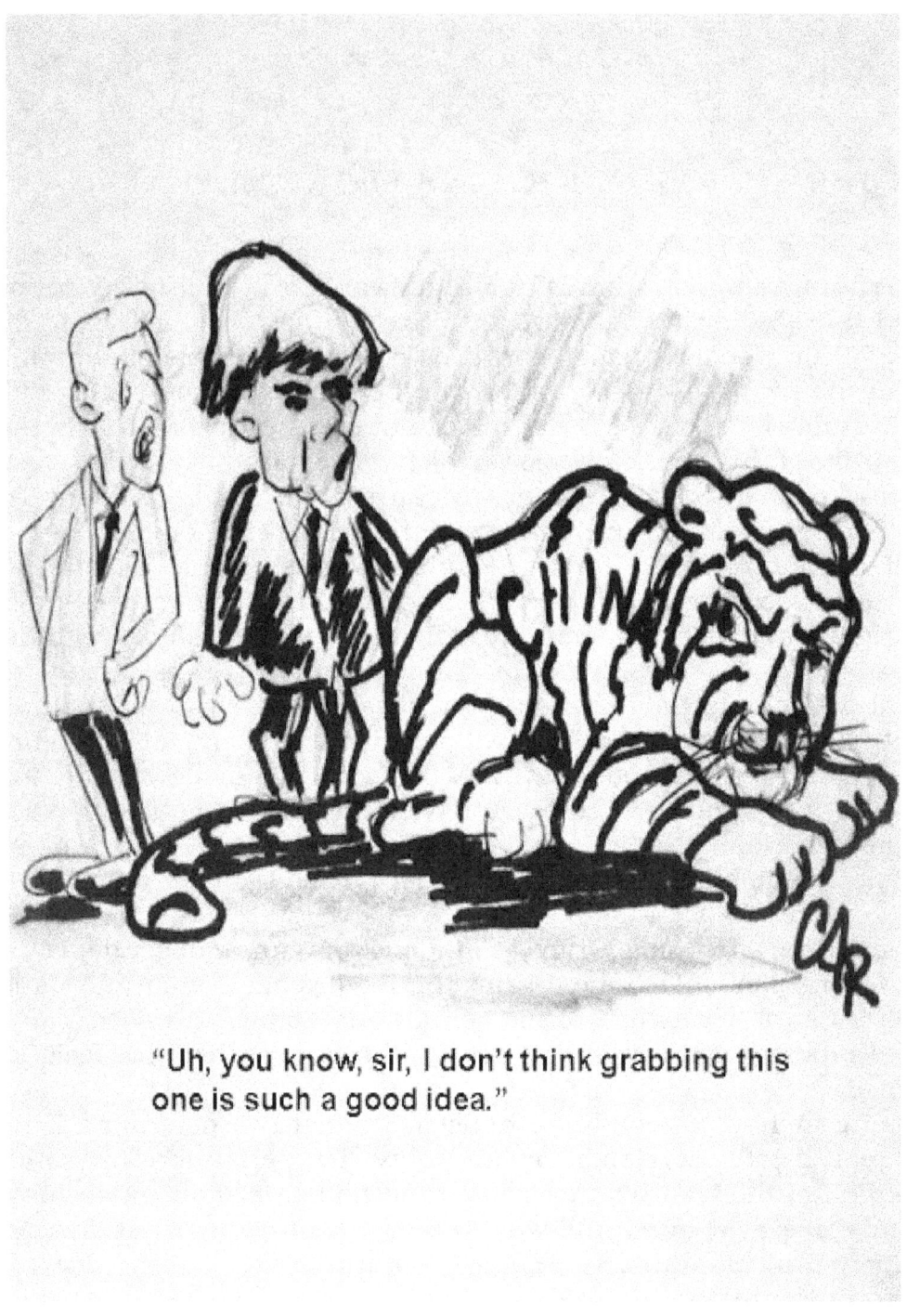

While there's no doubt that the Chinese economic tiger has misbehaved, grabbing it the way Trump likes to do, might not be the best idea.

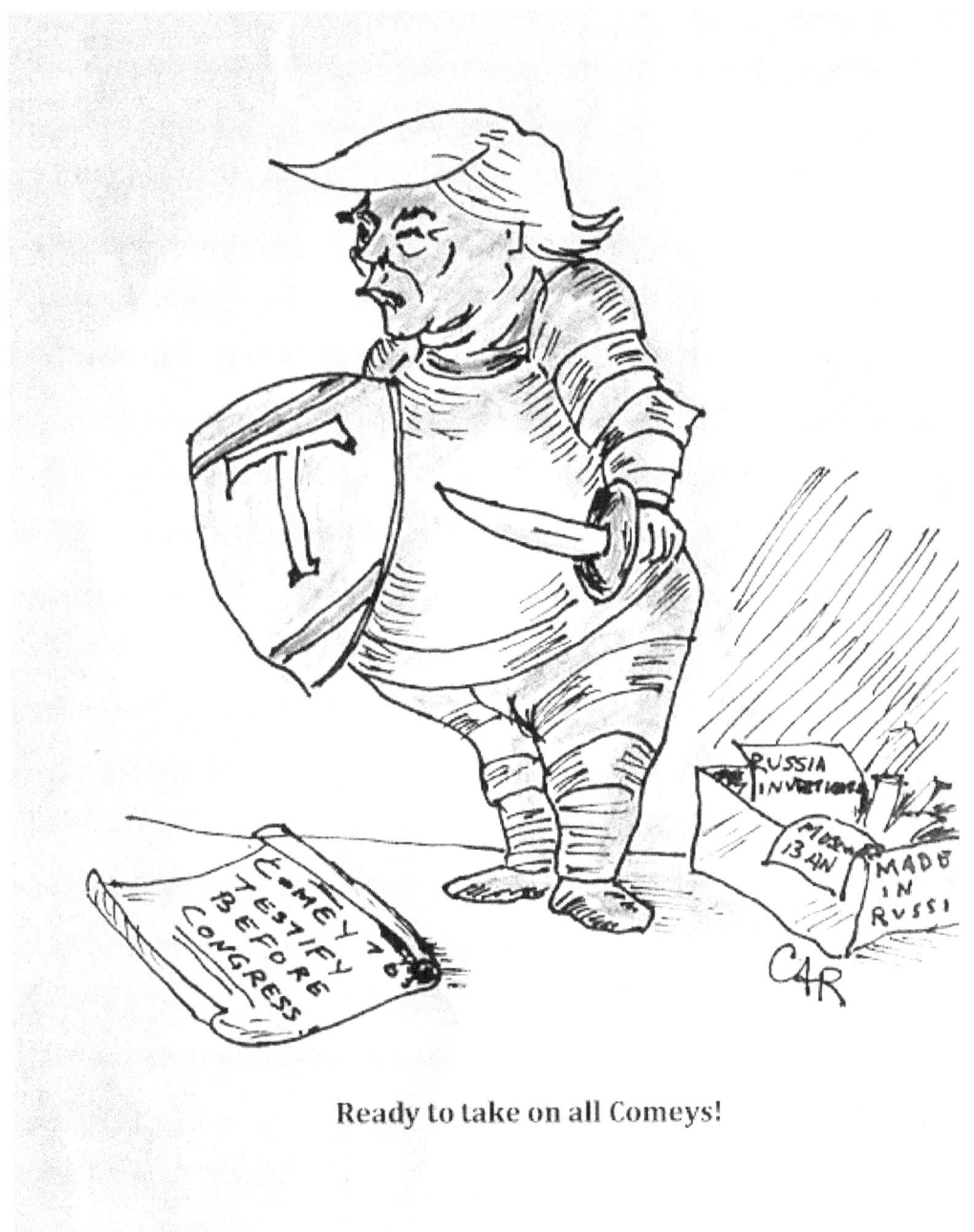

Ready to take on all Comeys!

Trump will continue to take everything personally, and lash out whenever he feels threatened.

During a surprise Christmas 2018 visit to troops in Iraq, Trump turned it into a campaign event by signing copies of his MAGA cap—and trying to portray it that that many troops just happened to have the damn things handy—and then later during a meeting with personnel in the Pentagon, he went on at length about political topics, much to the consternation of many of the senior officers present. The man just doesn't seem to understand, or care, that such behavior and use of our military is highly inappropriate. In response to this, I penned the following little essay:

Politicization of the Military – Playing with Fire

Of the many unusual and troubling things that Donald J. Trump has done since becoming president, one that particularly troubles me is his using interactions with U.S. military forces and individuals like campaign events Ranging from signing MAGA caps during his Christmas visit to troops in Iraq to using a recent Pentagon visit to lambast his political opponents, Trump's actions are blatantly partisan and definitely inappropriate.

Since George Washington's speech to army officers meeting in Newburgh, New York in March 1783 to discuss possibly defying the U.S. Congress over its failure to provide back pay due them, in which he opened with the statement, 'Gentlemen. By an anonymous summons, an attempt has been made to convene you together, how inconsistent with the rules of propriety! How unmilitary~! And how subversive of all order and discipline . . .' In a long speech, Washington dissuaded the disgruntled officers from carrying out what would have been, in effect, a military coup, and since that time, keeping the military shielded from partisan politics has been a fundamental part of the military profession.

In addition to time-honored tradition, there are also legal and regulatory controls and restrictions regarding the military and political activity. Article II, Section 2 of the U.S. Constitution states, 'The President shall be the Commander in Chief of the Army and Navy of the United States, and of the Militia of the several States, when called into the actual service of the United States. This clearly establishes civilian control of the military, and makes clear that the military must obey the legitimate orders of the civilian authority. Article 88 of the Uniform Code of Military Justice (UCMJ) states, 'Any commissioned officer who uses contemptuous words against the President, Vice President, Congress, the Secretary of Defense, the Secretary of a military department, the Secretary of Transportation, or the Governor or legislature of any State, Territory, Commonwealth, or possession in which he is on duty or present shall be punished as a court martial may direct.

It is abundantly clear from all this that through law and practice, it has never been intended that the military forces of the United States should be used for political purposes. For a president, therefore, to so blatantly introduce the partisan into his interactions with our active duty military forces is troubling on many fronts. For one, it is, in my view as a veteran of 20 years of military service, a violation of one of our most sacred positions. It puts military personnel in an uncomfortable and potentially untenable position. They cannot, by regulation and tradition, rebel against the commander in chief—the best that they can do, as was demonstrated in the recent Pentagon appearance, is to stand silently and respectfully. I fear, though, that there is an even

greater danger. As traditional behavioral norms are slowly cast aside, and the unthinkable becomes more publicly acceptable, this constant political manipulation of the military has the potential to shift the military closer to the political sphere. In a country where the military's role is to defend the country, not to serve a particular political party or individual, this is dangerous. To those who say it could never happen, I merely point to the events of 1783 to show that, without the intervention of George Washington, it *could* have happened early in our history.

It is incumbent that those who have the president's ear; the secretary of defense, GOP members of congress, such as Senator Lindsey Graham (who is himself a military veteran) to point out to him the potential danger of his actions, and persuade him to cease and desist.

Words have consequences, and actions cause reactions. We have spent over 200 years building a democratic system that is (was?) the envy of the world. It behooves us to do everything possible to ensure that that work is not undone during one four-year period.

I sent the piece above to the *Washington Post* as an op-ed, but received no response, so instead, I share it here, and have posted it on my blog, 'Free flow of ideas is the cornerstone of democracy' at https://charlesaray.blogspot.com/.

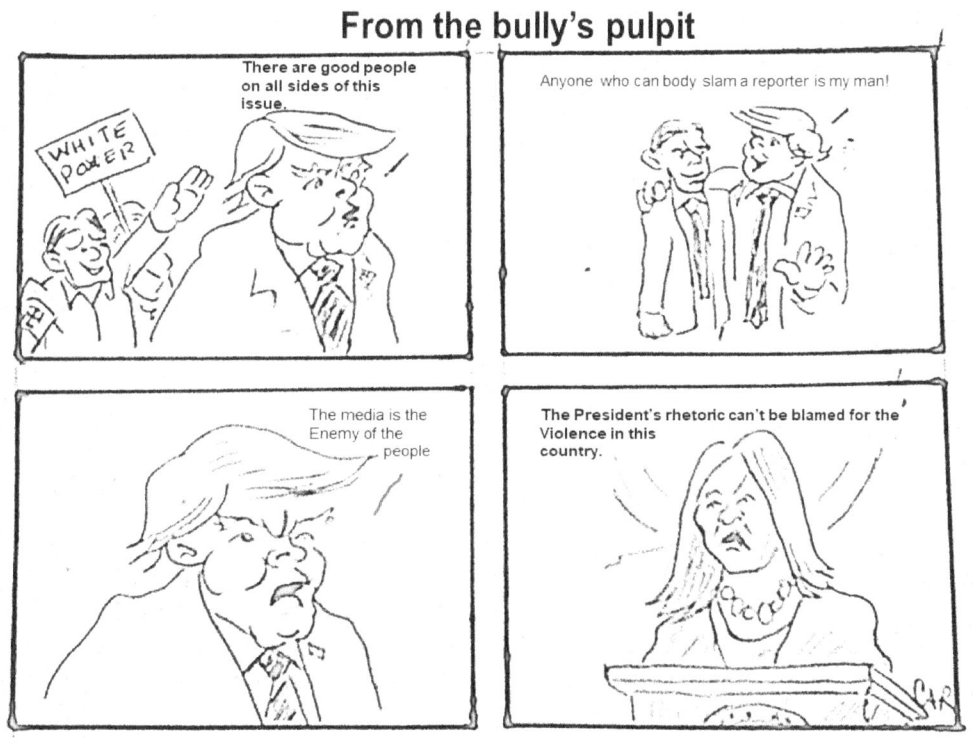

Trump continues to provoke, and his enablers continue to make excuses.

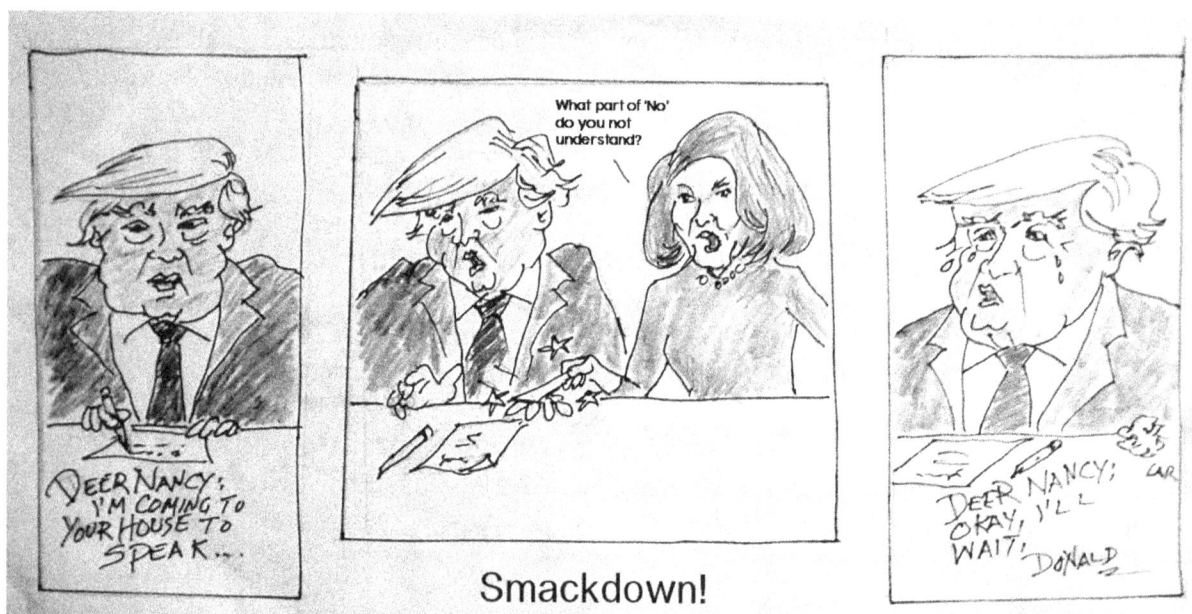

House Speaker Nancy Pelosi opened a giant-sized can of whup-ass during the partial government shutdown, demonstrating that political negotiating is not the same as negotiating a real estate deal. The question is, though, will he learn from this? I doubt it.

Make America Good Again

Here's the slogan we should be quoting. We've always been great, but sometimes, not so good.

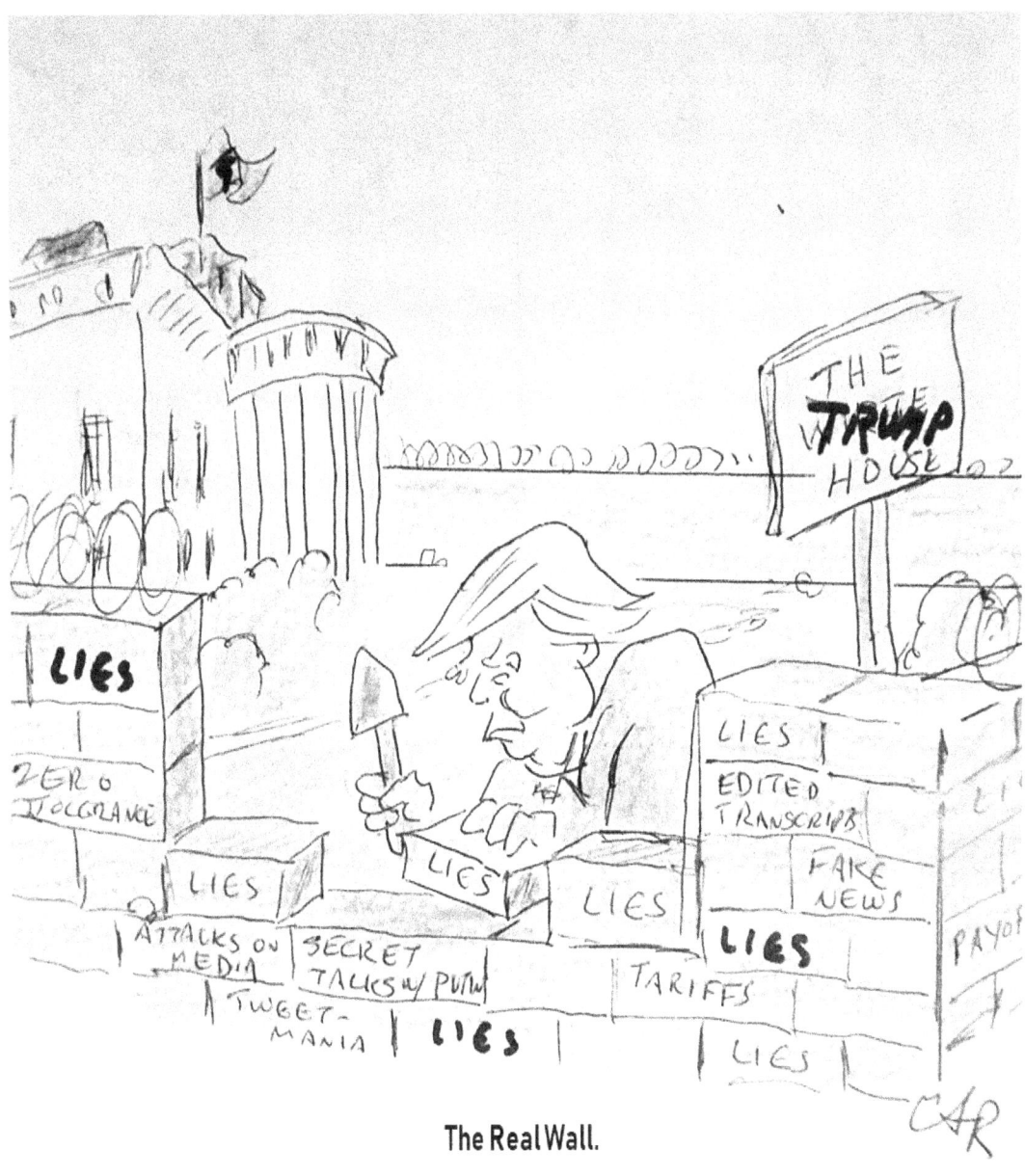

He's fixated on a wall on the southern border, all the while he's building a wall separating the American people from their government.

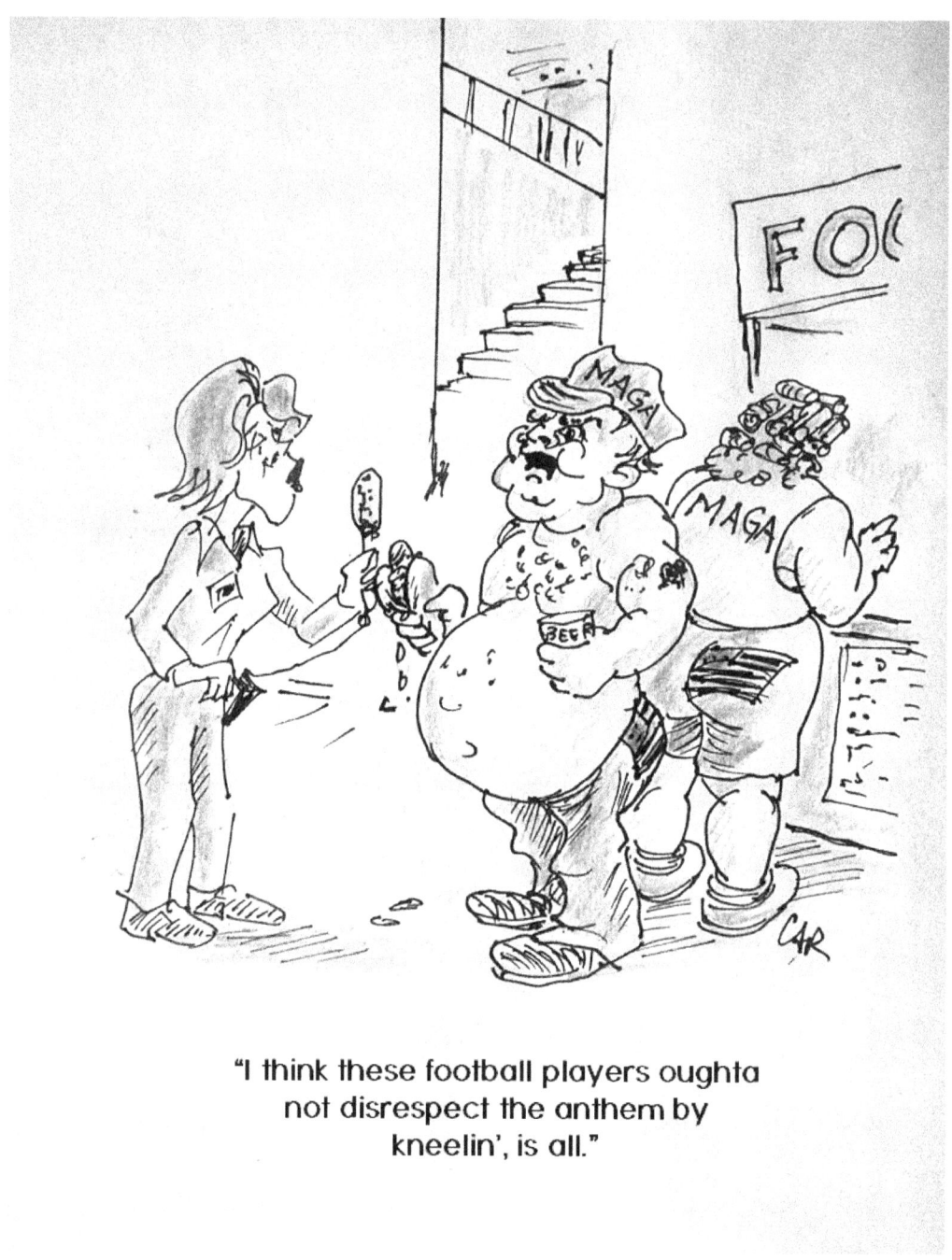

If he thinks his base is interested, there's no argument too petty for him to enter, including the one swirling around NFL players and other athletes expressing their views peacefully.

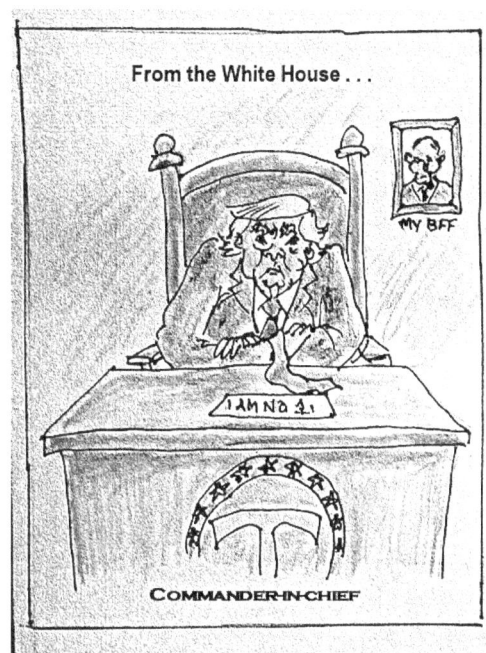
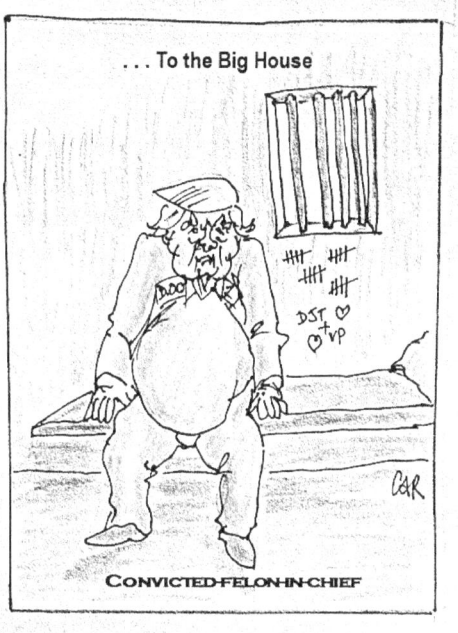

With more and more of his close associates being convicted, or pleading guilty to crimes, and investigations in New York having nothing to do with impeachment or Russia, this is not as improbable as it might first seem.

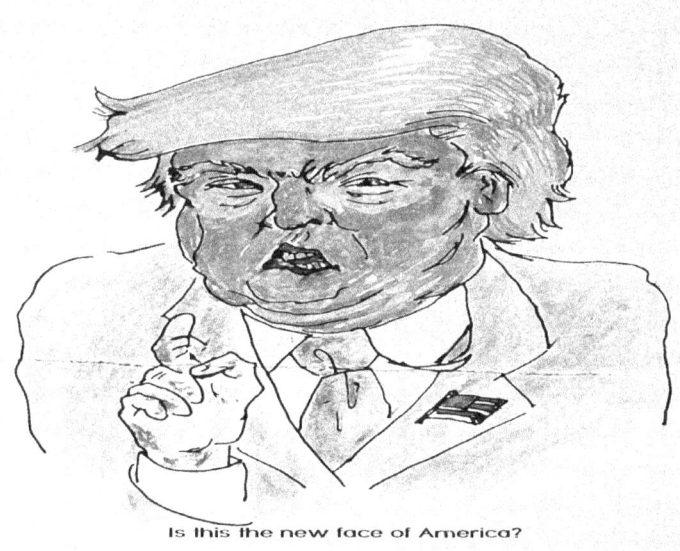

Hate him or love him, for better or worse, I predict we're stuck with this joker for another two, turbulent years.

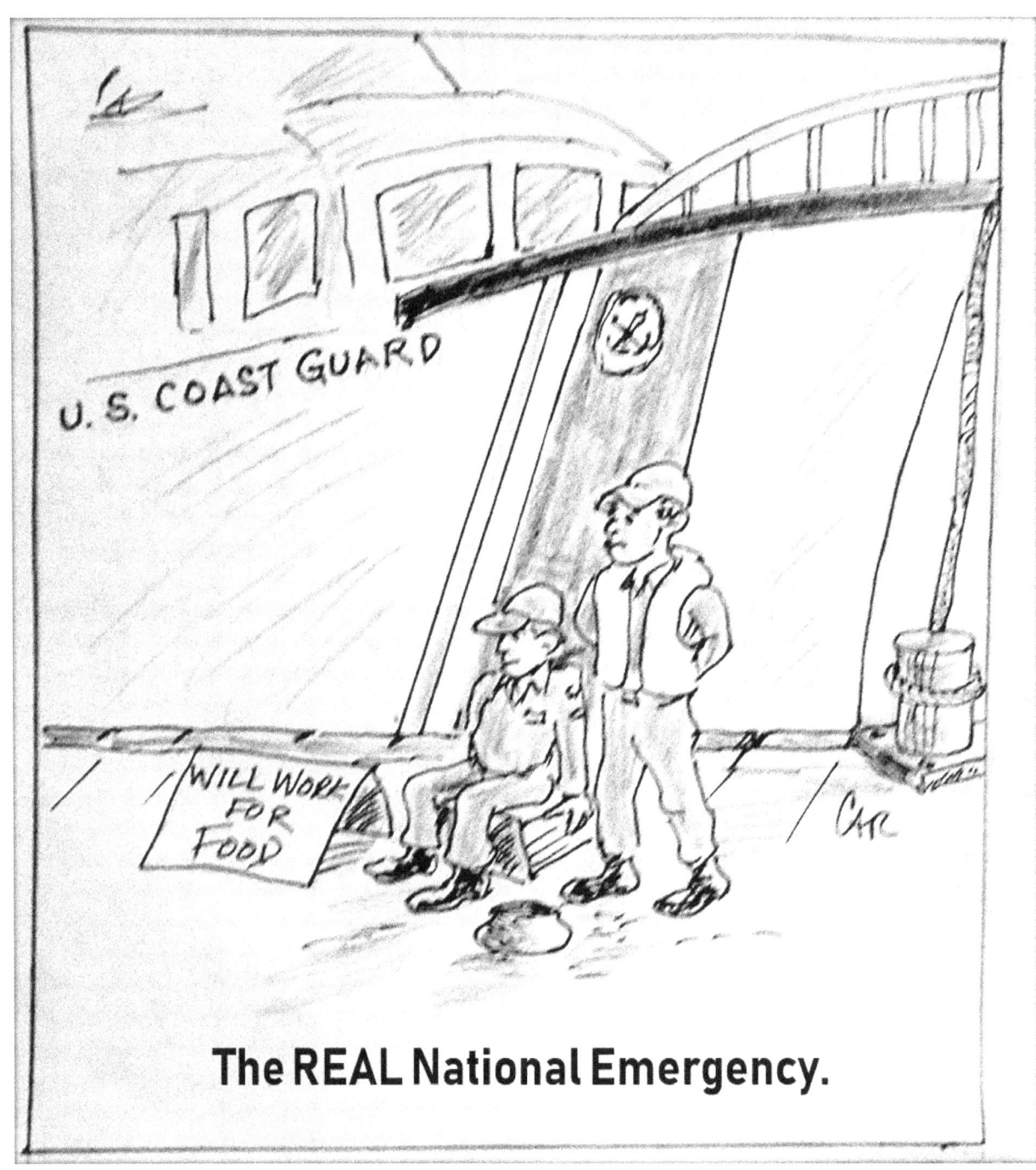

We might have to endure more government shutdowns.

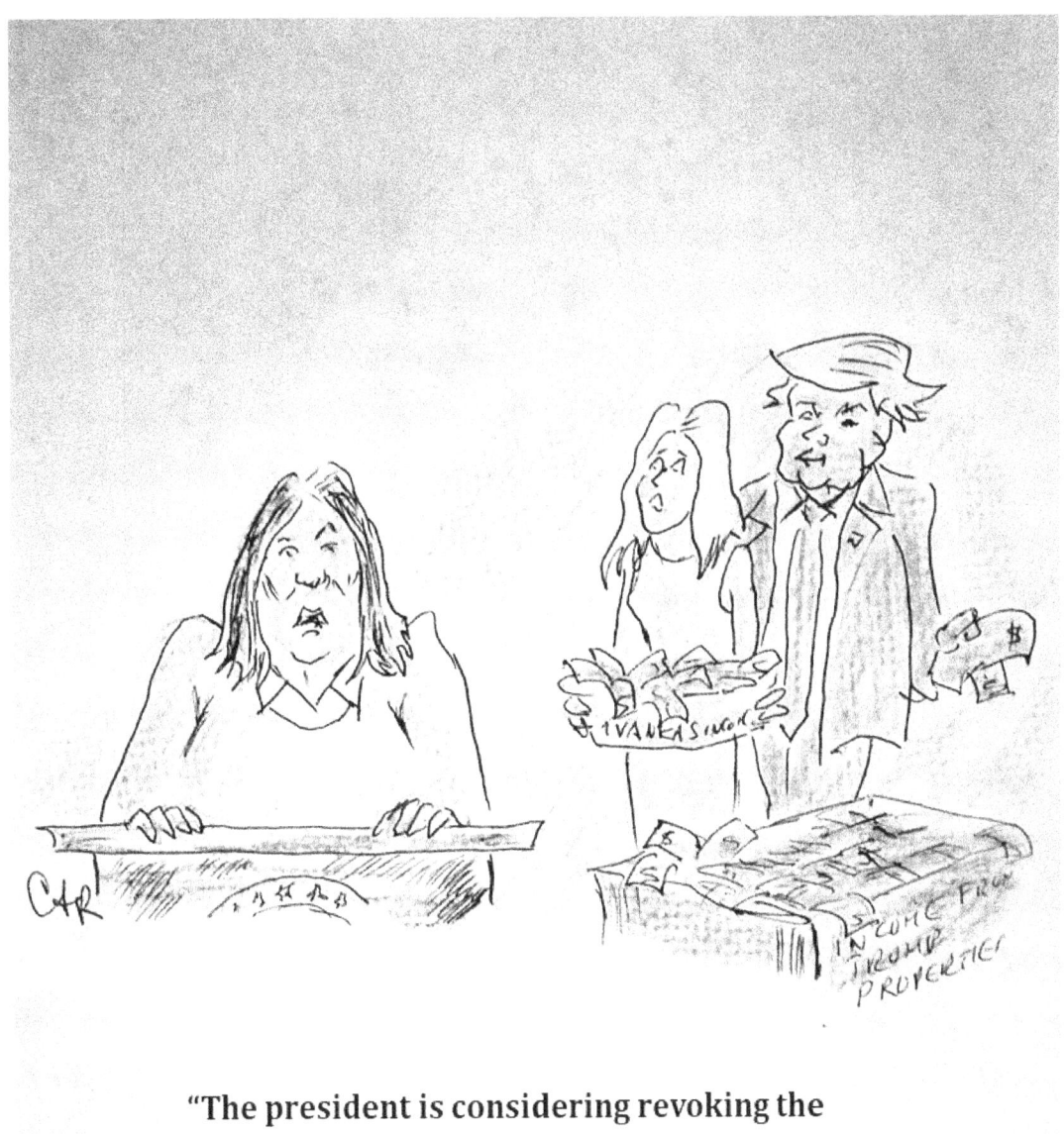

"The president is considering revoking the security clearances of several former government officials because they have monetized their positions."

Translation: those who disagree with or criticize him. His son-in-law, though, who couldn't otherwise get a security clearance, got one anyway. Look for more of this for the next two years.

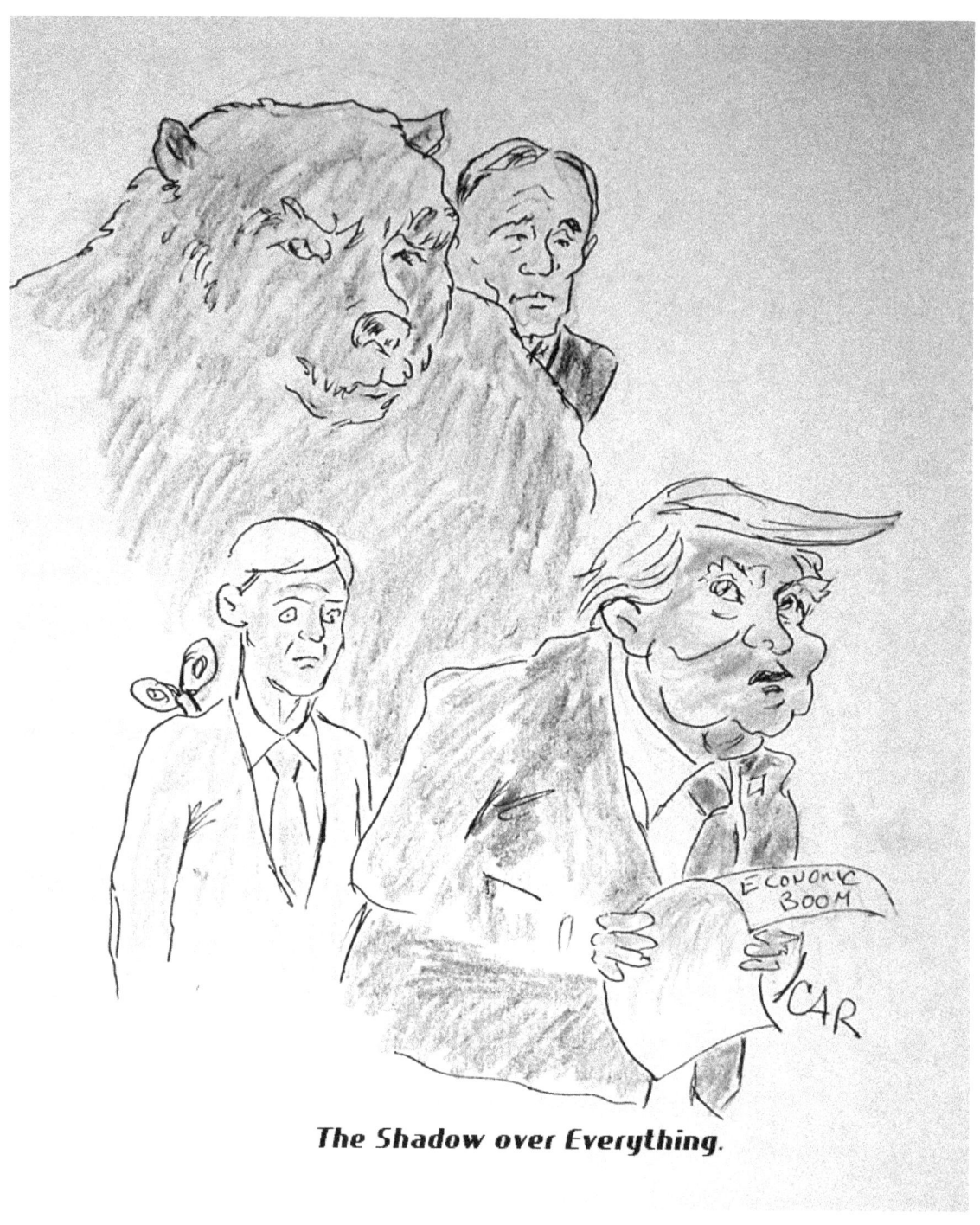

The Shadow over Everything.

As much as Trump would like the Russia issue to go away, it's not. Even when the Mueller investigation is ended, questions will remain – Trump's own actions will see to that.

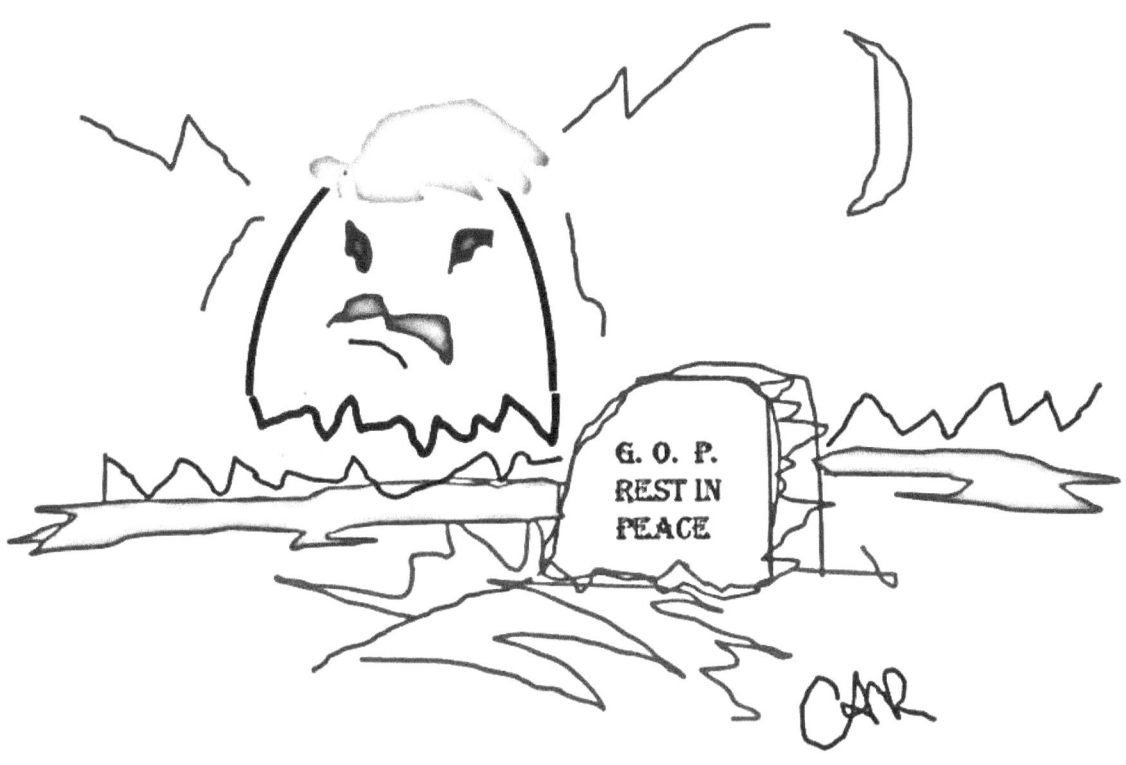

 There will continue to be outbursts due to his thin skin and super-sized ego, and the GOP will continue to suck it up. Mark my words.

AND, THAT IS AN ALTERNATIVE FACT

Another one of my memes showing another thing we'll have to deal with for two more years.

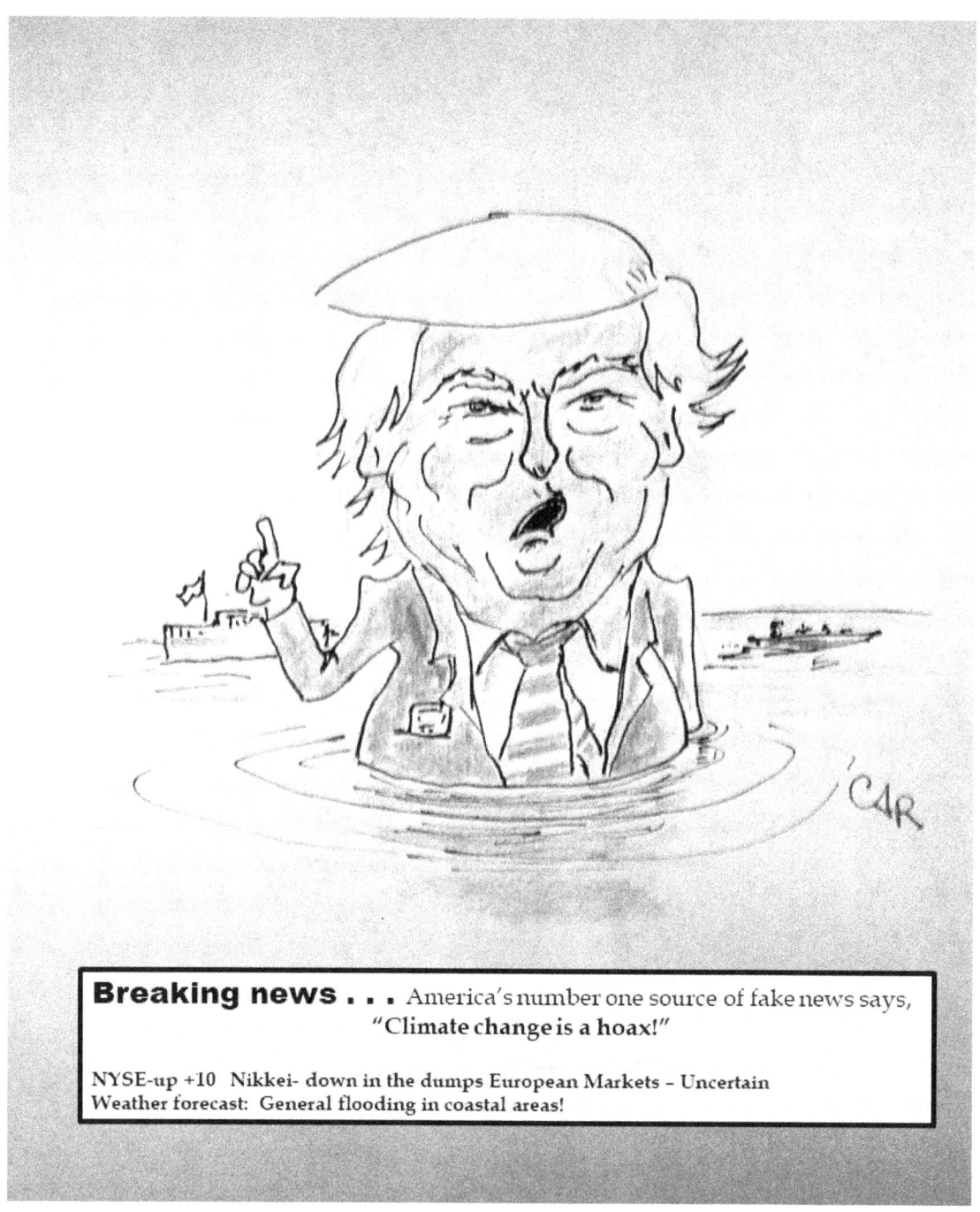

In the face of voluminous scientific evidence, along with many others, he continues to deny climate change.

"Uh, yeah, I know he insulted my wife, but, uh, I'm just a forgiving kind of guy, you know."

For crass political reasons, people like Ted Cruz, who Trump savaged in the 2016 campaign, now pledge fealty to him as if nothing happened.

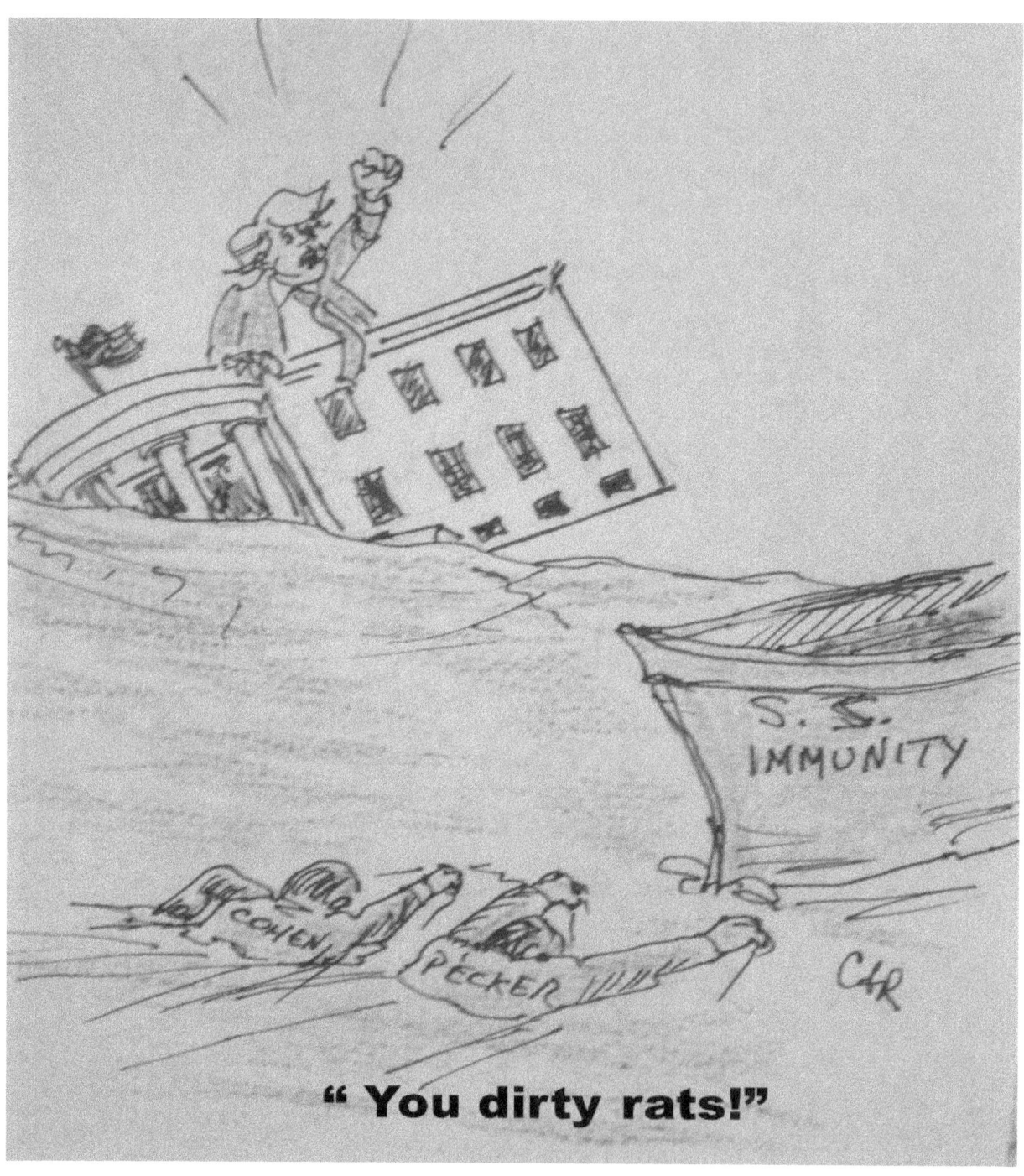

In the meantime, with convictions, guilty pleas, and cooperation with authorities, some of his closest confidantes are being removed from the playing field – and it infuriates him.

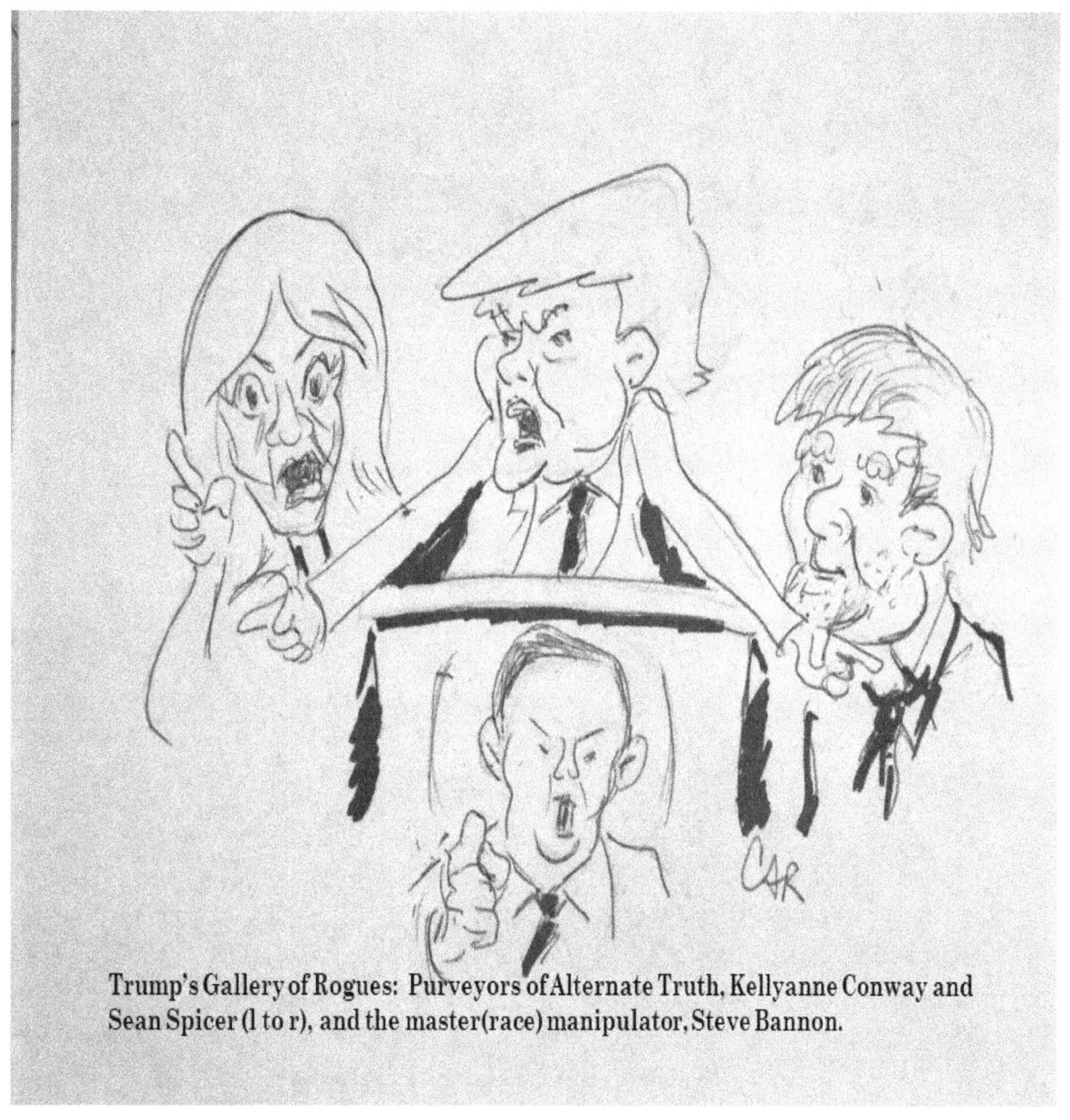

Trump's Gallery of Rogues: Purveyors of Alternate Truth, Kellyanne Conway and Sean Spicer (l to r), and the master(race) manipulator, Steve Bannon.

Spicer and Bannon were shown the door, but have been replaced by equally odious personalities. In the meantime, Conway continues to act at Trump's attack dog.

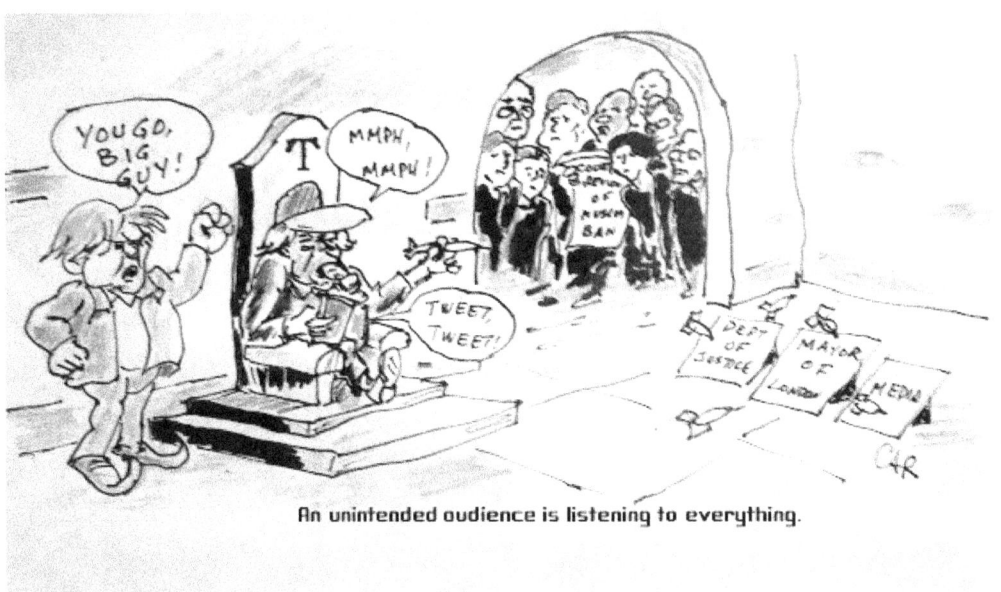

An unintended audience is listening to everything.

Trump's going to continue to tweet to his base, ignoring the larger audience that's listening.

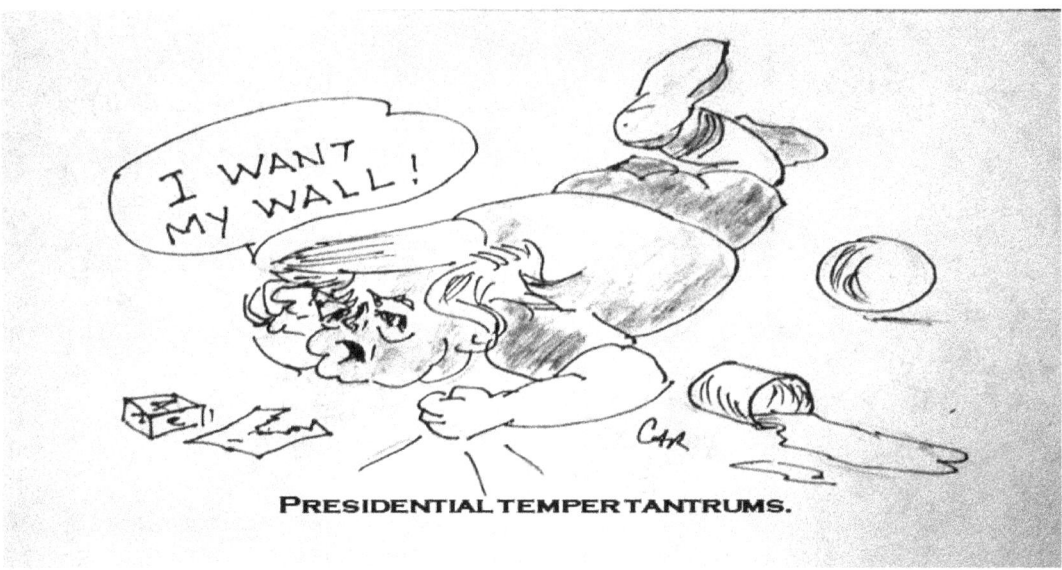

PRESIDENTIAL TEMPER TANTRUMS.

And, unfortunately, during the final two years of his tenure, we can expect more tantrums, if not about his border wall, something else.

OTHER SWAMP CREATURES AND THINGS THAT BOTHER ME THAT HAVE NOTHING (OR LITTLE) TO DO WITH TRUMP

Anyone reading my posts or seeing my cartoons on my blog, 'Free flow of ideas is the cornerstone of democracy,' https://charlesaray.blogspot.com/ since 2016, will probably think I'm suffering from Trump Derangement Syndrome (TDS). That's what the Trump trolls sometimes say whenever I post something critical of the Donald on Facebook. I'm not so sure I can argue with them either, because the man's crudities, lack of empathy, and ego-driven antics rile me even more than Tricky Dick Nixon did—Nixon was a crook, but he at least loved his country more than money. I'm not sure Donald Trump loves anything but himself, winning, and making money, in that order.

All this notwithstanding, there are many other things that get my dander up, and a closer reading of my blog will reveal most of them. I hate bureaucrats who become obsessed with advancement and perpetuation of their bureaucracy instead of serving the people who pay their salaries—the American taxpayer, and I see red every time there's another questionable police shooting of an unarmed person (usually a young black man), and the thin blue line closes ranks and tries to demonize the victim. I'm a firm supporter of the #MeToo movement. For far too long, men in power have taken the attitude that they can get away with anything, and I, for one, am happy to see some of them get their comeuppance.

American apathy about the world, until it affects their TV reception, scares me. Whether we like it or not, whether we know it or not, what happens in other parts of the world does impact our lives, often indirectly and long after the original incident, and all too often we're too dumb or blind to recognize it. I'd like all of us to live by the adage, 'injustice against one is injustice against all.'

I am also driven to fits of anger and depression by people who deny climate change and the role that human actions play in it. The science is clear, even to a non-scientist like me. I also realize that life exists on this planet because a whole host of things are in delicate balance, and uncontrolled global warming can upset that balance. Reach the tipping point, and you don't get a mulligan; the game's over. I would like to know that I'll one day be leaving my grandchildren a planet that they can leave to their grandchildren.

The following pages, in word and picture, are some of the other things that bug me.

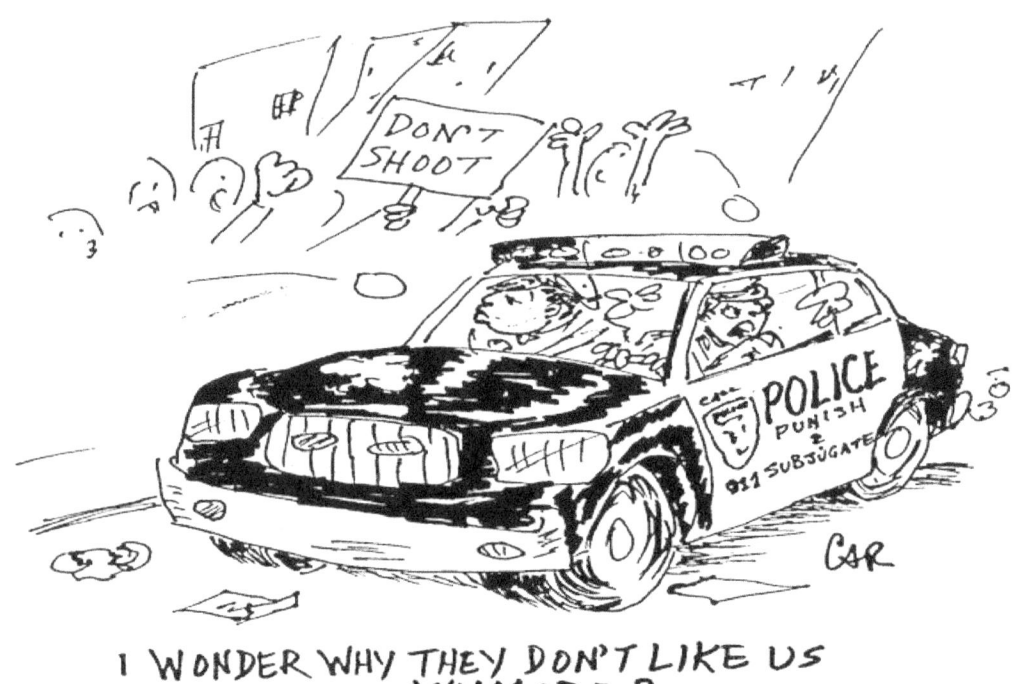

The cartoon above and the following blog post, 'Black Communities and the Police: The Source of Out Discontent,' was done in response to the public reaction to several police shootings of unarmed young black men under questionable circumstances. Since this first appeared on June 12, 2015, there have been more, and few have resulted in punishment of the perpetrators.

I have the utmost respect for honest, hardworking cops who put their lives

on the line to serve and protect the public, but I would like to see police forces around the country take more positive action to ensure that every member of the force knows and lives by the motto, 'Protect and Serve.'

A good start would be a scaling back of the militarization of police forces. When I ride the Washington DC Metro and see Metro Police on the platform in armored vests and helmets, I'm not really reassured. I understand the perils of police work. Too many guns in the hands of people who shouldn't have them. There's a solution to that if politicians would quit hiding behind the Second Amendment and quaking at the prospect of a bad grade from the NRA. I'm not against gun ownership, but like cars, there should be rules and requirements, and they should be enforced. I'm a realist, though, and I know that if several school shootings haven't changed minds, probably nothing will and the vicious cycle will continue to repeat.

At any rate, here's my view on the history of policing in the U.S., and one, among many, reasons for the tension between the police and minority communities.

<div style="text-align:center">Black Communities and the Police"
The Source of Our Discontent.</div>

The increasing number of incidents in which police kill civilians, especially young black men, whether justified or not, has raised in my mind the precarious state of relations that exists between the police forces and black communities in our country.
While it's tempting to blame these incidents on institutional racism and individual bigotry—which, by the way, do play a significant role—even a brief study of policing in the United States yields a far more disturbing answer.
As with many other governmental institutions, law enforcement in the new United States was based upon the English model, thus the presence of sheriffs as chief local law in many places. Initially in the colonies, maintenance of order was the responsibility of Justices of the Peace, but as towns grew, so did the need to maintain law and order. Until 1833 this was done by watches, or groups of community volunteers, who responded to or warned of danger. As more people crowded into towns that grew into great cities, anti-social behavior and criminal activity also grew. In 1833, Philadelphia, PA organized the first 24-hour per day, independent police force. New York City followed in 1844 with two forces, one with day duty, and a night watch. By 1880, most of America's major cities had an independent police force.
These early forces were led by men appointed by the politicians in power, and answered to them—and to the moneyed mercantile interests behind the politicians. Their mandate was to maintain public order and respond to disorder; of course, what this meant depended upon who defined 'disorder.' What they were not organized to do was protect the people of the communities. Instead, there job was to stem labor unrest and maintain order in the immigrant, working class, and free black communities so that the mercantile interests would be able to make profit without hindrance. This was, you must remember, a time of

great labor unrest brought on by exploitation by bosses and terrible working conditions in mines and factories. In the south, the direction of the police was even more ominous. In the antebellum south, slave patrols were organized to 1) catch runaway slaves, 2) suppress potential slave revolts, and 3) intimidate the slave work force to keep it docile and working. After the Civil War, police forces in the south were used to keep free blacks 'in their place,' and enforce Jim Crow laws.

Since 1855, the Supreme Court, for instance, has ruled that the police have no duty to protect individuals, that they only have a duty to enforce the law in general. In some jurisdictions, police are also entitled to protect private (read commercial) rights.

As you might imagine, the early police forces were hotbeds of corruption, and were noted for their harsh and often violent treatment of members of the community—not just the black community either. White immigrant workers were often the target of harsh police crackdowns. The police forces were housed in barracks on the outskirts of cities, for instance, to keep them from mingling with and becoming sympathetic to the populations, which they were there to control, not protect.

In response to police brutality there have been many moves to reform America's police institutions. What has often been the result of these reform moves, though, is further separation of the police from communities—especially minority communities.

Distrust and fear of the police has only deepened since the 1950s when militarization of the police began. The introduction of uniforms, military ranks, chains of command, and deadlier weapons, only serves to further alienate police forces from the communities they claim to 'serve.' Since the September 11, 2001 terrorist attacks, with the Department of Defense providing combat arms and equipment to local cops, it has gotten even worse. No one can forget the image of cops in Ferguson, MO, riding armored vehicles and armed and armored like combat troops in Afghanistan, facing off against unarmed demonstrators.

Regarding the police and minority communities, looking at the demographics of America's local police organizations gives further cause for worry. The following statistics are a couple of years old, but the situation hasn't changed significantly, so they tell a chilling story:

Approximate number of police officers in the US – more than 800,000 (in 2008) for nearly 400 officers per 100,000 population.

 Average salary - $60K/Yr (New Jersey - $89K, Mississippi - $33K)

 Police officers killed per year (2008) – Between 70 and 80
 People killed by police per year (2008) – 600

 Public confidence in police – 54% (less than the military, but more than Congress)

 Key demographics of our police officers?
 Race: White – 80% Black – 16% Hispanic – 13% Asian – 2%
 Education: High School – 20% Some College – 44% College grads – 36%

When all this is taken into account, the conclusion is that it would be a miracle if relations between police organizations and the black community were amicable. The fact is, if you

analyze the history of policing in the United States, it is a wonder that the police are welcome in *any* working-class community.

The question before us, then, is what can be done about it? I'll be the first to confess that I do not know. Efforts at community policing are a step in the right direction. But they must be reinforced with evidence that the police truly are sworn to *serve and protect* and not subjugate and punish—not there to ensure that the workers are kept in their place so that the mercantile interests (the 1%) can have a stable, orderly work force and tax-supported protection of their interests, enabling them to get ever richer. The militarization of our streets must end. And then, the process of healing can begin.

I am not naïve. I know there are lots of violent criminals out there. I know that there are far too many guns on the streets, in closets, gun cabinets, and under beds. I know that the job of a police officer is dangerous, and often thankless and under-compensated. I know that there are decent, dedicated police officers out there who put their lives on the line daily on behalf of the rest of us. What we need to do, though, is root out the rotten apples, so the good cops can do their jobs.
I don't know how long this would take. I do know it won't be overnight. It's been in the making for over 200 years—since the first police force was organized—so, it might take that long, or longer, to fix the problem. So what? It needs to happen, and it's not a problem that can be solved by one side. It will take both—the police and the community—working together.

What say we get started today?

On the following page is a cartoon I did called 'I Support the Right to Arm Bears.' A play on words, and meant as a joke—sort of—it's sure to earn me an F from the NRA should I ever decide to run for public office. Of course, if I ever to that, I hope that bear shoots me.

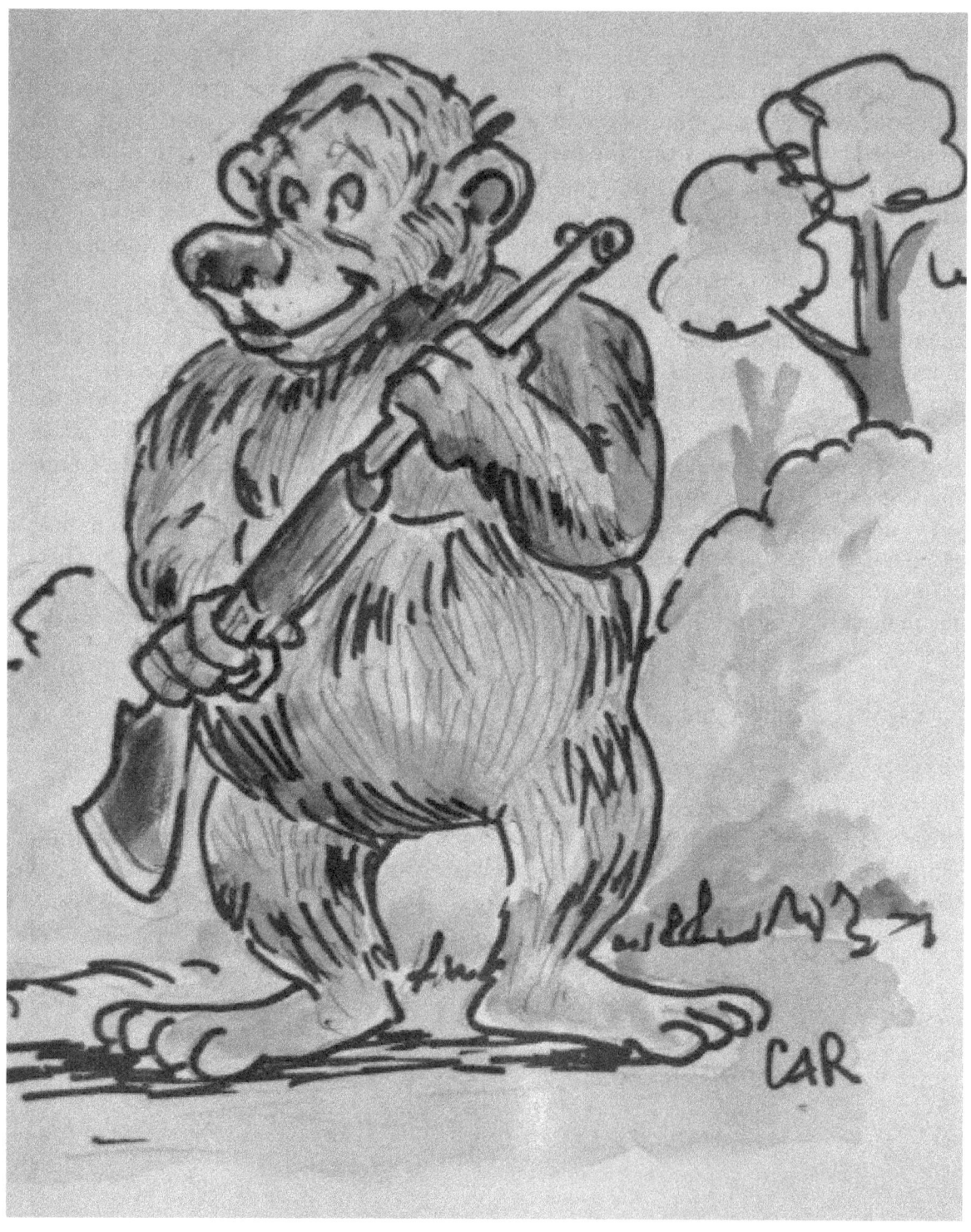

I Support the Right to Arm Bears

AUTHOR'S NOTE

If you've turned pages to this point, I'm assuming you were not overly offended by my art or my words. The opinions expressed here are mine and mine alone—well, actually, I know a lot of people who agree with me, like most of the 7,000+ people who follow me on Facebook, and another 4,000 or so on Twitter. My intent here was not to offend but to inform, to offer up another view on events for consideration. If the contents provoke debate and discussion, great. That's really the intent of editorial cartoons and op-eds. Of course, trolls, who dissent just for the sake of dissent, and who bring nothing of value to the debate, need not apply. For the rest of you, whether you agree or disagree, take a few minutes and leave a short review on Amazon, Goodreads, or whatever site you obtained this book from. As an independent writer, I thank you.

ABOUT THE AUTHOR

Charles Ray has been writing, drawing, painting, and taking photographs most of his life. In the 1970s he was an editorial cartoonist for a small weekly newspaper in North Carolina, where he incurred the ire of the town council over a series of cartoons taking issue with a tax measure they forced through without the consent of, or consulting with, the citizens of the town. The measure was ultimately defeated, not really because of his barbed cartoons, but because the citizens rose up in righteous anger, but he likes to think that maybe they did play a small part.

His first published writing was a short story that won a national Sunday school magazine short story contest when he was thirteen. Seeing his name on a story read by thousands of people hooked him forever on writing, and after graduating from high school and joining the army, he spent the next twenty years freelancing and moonlighting as a newspaper and magazine journalist, artist and photographer.

After retiring from the army in 1982, he joined the U.S. Foreign Service, and spent the next thirty years as a diplomat, serving in Asia and Africa, and eventually tried his hand at a book-length project, a book on the leadership principles he learned from his grandmother. Fiction followed, with a mystery novel set in the Washington, DC area, and later a western/historical fiction series about the army's Buffalo Soldiers on the western frontier.

He has written over a hundred books of fiction and nonfiction.

A native of Texas, he now calls suburban Maryland, just outside the nation's capital, home.

www.ingramcontent.com/pod-product-compliance
Lightning Source LLC
Chambersburg PA
CBHW081617220526
45468CB00010B/2915